KEITH TYSON

KEITH TYSON

GENO PHENO 1 **NOVEMBER 3, 2004–JANUARY 8, 2005**

HAUNCH OF VENISON ❚❚⁄

6 Haunch of Venison Yard / London W1K 5ES / United Kingdom

KEITH TYSON

GENO PHENO 2 **OCTOBER 15–NOVEMBER 12, 2005**

PACEWILDENSTEIN

534 West 25th Street New York NY 10001

Sea-gherkins! . . . Freshwater swabs! . .

Ectoplasms! . . . Bashi-bazouks! . . .

Blue marble. The top part of it looks like one of those old fashioned diving helmets fed with air pumped through a rubber tube by someone on the deck of the ship above. But for the fact that it is so spotless and beautifully machined you would think of Tintin looking for Red Rackham's treasure, perhaps, or a tense scene in a black and white action film just before the baddy cut the air line. It is a metal sphere with a number of circular portholes through which you can peer to see that there is nothing inside. There are some other valve holes, and from their presence we infer that the object might be put to use in some process involving the feeding into and exhausting from the chamber of various fluids. But these are all sealed with metal caps, so it remains isolated from everything apart from the base to which it is attached. The sphere sits on top of a brushed metal cabinet inside which, its low hum tells us, there is something going on. But as there are no dials, no displays no gauges, no meters, exactly what is happening remains obscure.

Keith Tyson has done something a little like this before with his *The Thinker* (p. 6, fig. 1). Made in 2001, the fabled year of Stanley Kubrick's *Space Odyssey*, it was a tall, black monolith akin to the one featured in the film. Implacable and inscrutable, the only evidence that it contained more than it was letting on was the emission of a continuous low hum from the computers housed within. The problem they were working on was not vouchsafed, one knew simply that there was a problem otherwise they would not be working on it. With a title like *The Thinker*, we must see the work as a self-conscious allusion to Rodin and, through him, to the Renaissance tradition he was re-examining, albeit that such a tradition arrives at Tyson having been filtered through Duchamp's *With Hidden Noise*. Rodin's own works following from his *Thinker* moved, in William Tucker's words, 'in the direction of an increasing abstractness, towards the frank acknowledgement of an *internal, sculptural* order which evoked rather than represented the figure'.[1] When we stand in front of this sphere, though, the parameters have changed. We cannot possibly be dealing with anything like an internal, sculptural order, because we can see right inside the object, and there's nothing there.

There is a title, though—*Solar Powered Vacuum* [plate 56]—and this does offer a clue. An explanation of the set-up tells us that there is an array of solar panels placed on the roof of the gallery. Power generated in these cells is fed to the pump housed inside the cabinet, which works to create a vacuum inside the sphere. The vacuum is intense, equivalent to that found in interstellar space, but of course you have no way of verifying that. All you can see when you look through the porthole is an empty spherical chamber, and maybe the face of someone else as they look in from the other side. If the day is cloudy it might also be that the panels are unable to generate sufficient power to maintain the

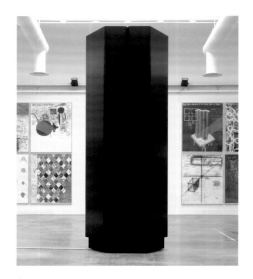

fig 1:
The Thinker (part of Seven Wonders of the World), 2001
enamel sprayed aluminum, steel, computers and software
118 x 49 ¼ x 43 ¼" (3000 x 1250 x 1100 mm)
Collection Thea Westreich and Ethan Wagner, New York

6

vacuum at the required level, so it is perfectly possible that you are not looking at a vacuum at all. You have to trust that it is so, and recognise that if the weather is fine and the machine is working properly what you are looking at is nothing, and if the weather is poor, then you are most likely just looking at a metal sphere with a bit of air in it. That is, you are looking at something. It is art when there's nothing.

Solar Powered Vacuum is just one of a large number of works in Tyson's *Geno Pheno* series. As the overall title implies, the two part structure of each one comprises a genotype containing something akin to the 'genetic material' or the "coding" of the work, and a phenotype that constitutes the expression or working out of that material in physical, apprehendable form. The exact relationship between the two parts varies from piece to piece, but in each instance there is a double nature. In the case of the sculptures, this largely means that there is an object on a supporting plinth, the plinth being the "genotype" and the object the "phenotype," while the paintings are diptychs in which the left hand panel provides the genotype. The cabinet for *Solar Powered Vacuum* with its attendant power-harnessing array is thus its genotype, an arrangement of technologies that works to initiate the evacuation of the sphere on top. This having been said, though, it might be more accurate to say that there are not merely two, but three parts to each work. Inevitably, the phenotype as a working out of the genotype's potential will be understood to reflect back upon the genotype from which it stems, illuminating more fully its fundamental nature.

I have said that the phenotype is an expression of the genotype, and this is so, but that does not mean that the process is one shaped by an emotional response. It is, rather, much more like the way one speaks of a gene being expressed in the colour of a person's eyes and is somewhat akin to the manner in which Spinoza conceives the relationship between a substance and its attributes. Gilles Deleuze describes this relationship thus:

> Expression presents us with a triad. In it we must distinguish substance, attributes and essence. Substance expresses itself, attributes are expressions, and essence is expressed. ... The originality of the concept of expression shows itself here: essence, insofar as it has existence, has no existence outside the attribute in which it is expressed; and yet, as essence, it relates only to substance.[2]

In Tyson's case, in other words, the genotype expresses itself in the phenotype, which in its turn expresses the essence of the genotype. The sun produces the vacuum that reproduces the cosmic conditions in which interstellar dust gathers and fuses to form a new star (and possibly an accompanying solar system), that could in its turn produce the vacuum that ...

Solar Powered Vacuum generates many connections across art's territory, but there is one that I think is particularly significant. In both its form, and in the degree to which the viewer is confronted by the need to make a leap of faith in order to acknowledge it as a work of art, it resonates with Jeff Koons's *One Ball Total Equilibrium Tank*, and with other works he made in the mid-1980s—the bronze cast of the aqualung, the chromium-plated *Bunny*, the Jim Beam decanter train that remains a work of art only so long as you don't break the seal and consume the drink inside. *One Ball Total Equilibrium Tank* makes a wealth of allusions—it celebrates the wondrous aspects of human capability in the way that it evokes Michael Jordan's apparent ability to hang in the air, it points up the extent to which we perceive the world filtered and enhanced by the media in the way it "freezes" the ball just as TV would in order to let us see details of a basketball play more clearly, and it goes far beyond this to address more broadly how we understand the limits of our humanity. The basketball is the world, and we insistently question our place in, and relation to that world now that technological advancement has allowed us to see it, from the outside, as nothing more than a "blue marble" afloat in a sea of nothingness.

Solar Powered Vacuum picks up this question and runs with it. What is it to be human? What can assist us in attempting a definition in a world where the events, discoveries and technological developments of the passing days serve only to render hitherto firmly held beliefs as so much evidence of delusion and ignorance? What safeguards could there be in an environment that, on the face of it, becomes more unstable with each passing year? Curiously, it is that blue marble image of the earth that strikes us as more certain than most things. The photograph, AS17-148-22727, was taken from Apollo 17, the last manned mission to the moon, on December 7, 1972 at a distance of 45,000 kilometres from the earth.[3] In the 33 years since then, no human has been in a position to take a similar whole-earth picture, yet it continues to shape consciousness, if only as a reminder that what we see with our eyes and in our imaginations is never just brute earth but always a world.

□ □ □ □ □ □ □

$(6.6256 \pm 0.0005) \cdot 10^{-34}$ Joules seconds. One of the questions Tyson addresses is that of style. Is there some external force—issuing from, say, the market, or a dealer, or a critical consensus—exerting pressure on the artist to adopt one identifiable style and to stick to it? It wouldn't matter what that style was, just as long as it was consistently realised in work after work. Over and above their shared bi-partite structure, however, this is not the case for the works in the *Geno Pheno* series any more than it has been for Tyson's other work. On his own admission he has a great affinity for a radical simplicity deriving from his interest in conceptualism. We could imagine a show in which, say, *Solar Powered Vacuum* sat on its own in the centre of an otherwise empty gallery. Since it is about everything and nothing it could conceivably be thought to encompass all the world's possibilities. But even if that were so, it would only be one embodiment of the fact of those possibilities, which presents us with a choice. Either we agree with the idea that this is the best, and perhaps only, way to express the limitless possibilities of the world, in which case it will suffice, or we decide that it is only one way among many others in which such breadth of possibility might be addressed. For Tyson, each work is something like a model of the way things are or might or could be. None of them is to be thought of as more significant or as being closer to some transcendent truth than any other. They are of equal status as models.

And since *Solar Powered Vacuum* is not the grand unified artistic statement that trumps all possible others, since it is only one model among an infinity of possible others, one wants to set up, as it were, some kind of hypertext link to an infinity of other essays. To …

… an essay on quack diets, especially the efficacy of eating nothing but peas. *As Echoes Distort a Fortress* [plate 22] is a citadel on a rock, suspended upside down above a reflective surface across which ripples radiate on account of its having been lightly touched by the tip of the church spire. This essay would as likely as not recall the location in which Büchner's *Woyzeck* is set—a small town by a still pond. The establishing shot in Herzog's film of the play shows the town perfectly reflected in the surface. It would undoubtedly include something on Paul Celan's "Meridian" speech, given on the occasion of his receiving the Büchner Preis, and in which he discusses not only Woyzeck, but also *Danton's Death* and the *Lenz* fragment. Lenz was, Celan quotes, sometimes bothered "that he could not walk on his head." A man who can do that, he observes, would see the sky beneath his feet as an abyss.[4] This essay, as Celan's does, would need to address the nature and function of art. Two common alternatives are outlined in "The Meridian": either art as a Medusa's head, which freezes life for our perusal, or art as an automaton or marionette, which apes life's actions. The point, Celan says, is not to "enlarge" art through either of these methods, which is to say, simply to add to the stock of works, but to "take art with you into your innermost narrowness. And set yourself free/."[5]

… an essay on economic forecasting and futurology considering various models for predicting shifts in production patterns, market parameters, consumer demands, and so on. It would focus on *Chameleon* [plate 15], a plinth whose surfaces are offered for rent as advertising sites. It would spend a lot of time trying not to dwell on the most famous section of Benjamin's *One Way Street*—the one that says that advertising defeats criticism. There would be more interest in speculating how, say, global warming, or a steep rise in the price of oil might affect the economy, and how this would become evident in the changes among those institutions willing and able to buy the space for a period.

… an essay on things that, it can predict, will happen anyway; just as Slothrop's erections indicated the locations of forthcoming V2 attacks in *Gravity's Rainbow*. *Synaesthetic Turbine* [plate 60], with its tangle of Medusa's head serpents and roller-coaster track loops will be mentioned later in the essay you are reading now, but it would be interesting in this other essay that you will not read to pitch the cultural logic of the iPod shuffle facility against Schoenberg's contribution to that bible of synaesthesia, Kandinsky and Marc's *Blaue Reiter Almanac*, and to add in Adorno's championing of the Viennese composer in his *Philosophy of Music* and the essay "On the Fetish Character in Music and Regression in Listening."

… an essay in which everything would try its best to be black and white, like *7776+1 (Cutting the Fungal Cord)* [plate 6], which is black and white. It would be called "$(hg)^2$" on account of the detailing on the frame to the mini bandstand-cum-monster jardinière that houses the mushroom over the inky black pool from which a marble-white Tyson emerges. This all sits on a hexagonal, stepped black plinth, on every rising face of which is a phrase. A selection from these phrases provides the logic for the sculpture's narrative. The frame looks a bit like the art nouveau metalwork of the Paris Métro entrances, and a bit like material from the set of an *Alien* movie—Hector Guimard and HR Giger. So, try as it might, it wouldn't be black and white, it would be both/and instead of either/or. It would be fundamentally ambiguous.

It would be mercurial, Hg, and it would convey the weightiness of its subject matter—g, gravity—with the lightest and most economical of means—h, Planck's constant, the elementary quantum of action.

… an essay on all these things and more—on ambiguity, on art as something much more important than production for its own sake, on the abyss and a deft lightness of touch. *The Inertia of Desire (Worthless Fat Fuck with Nullifiers)* [plate 33] is a large stomach. It's not even a torso; no back, no indication of limbs or neck, just a blobby, unappealing gut. Considerably larger than life size, it is nonetheless convincingly life-like in its degree of verisimilitude. It is a monstrously hypertrophied Ron Mueck's *Dead Dad*, only more so. Too large, its bloated, overweight form lies on a carpet, spreading under the pull of gravity and surrounded by evidence of the sad, unhealthy excess that has got it to this state. Beer cans, and a half-eaten candy bar tell of drunken nights on which the only sustenance taken has been anything but a solid meal. Two band-aids stuck on the stomach tell of yet more unhealthiness, and hint at notions of puncturing and deflation. Being so heavy, it clearly smothers the carpet beneath, making sure that it won't fly: no imagination, no spirit, no transcendence, just a deliberate, despairing march into oblivion. The whole thing is a grandiose statement of the artist's perennial depressive nightmare that combines a frightening absence of ideas about what to make with the conviction that, even were one to think of something, it would be no more than an exercise in hubris to attempt its realisation.

But the beer cans and the candy bar, like the stomach, are marvellously well made. As well as Mueck, and a Kippenberger (self-) portrait, one thinks of Robert Gober's body parts and simulated objects, or of Elizabeth Wright and Simon Starling among other UK artists who have, in recent years, set a benchmark in such out-of-scale things that is being superseded here. And the beer cans and sweet wrapper are just the exact same shade of blue as you can see in the patterning of the carpet, and the weak flesh pink of the stomach, which tells of a lack of sunlight and exercise, matches the warm, rose-tinted cream that you find there too. Furthermore, the shape of the stomach distantly echoes those works of Richard Deacon which seem to hover in status between sculpture and plinth, though in *Inertia of Desire* the interdependence of carpet and stomach is now becoming clearer. The carpet is the plinth, but one that carries within itself the seeds of that which it supports.

While it may be that none of these many references are intentional in the sense of having been deliberately introduced during the work's planning and inception, they nevertheless constitute features in the cultural landscape in which we encounter it. Indeed, that they were not intentional allows us to see that the work, in its mix of maudlin self-pity, compensatory braggadocio and genuine reflection on the depths to which our fragile egos can plummet, is itself thoroughly intended. Far from being a gesture of abjection, *The Inertia of Desire* demonstrates, in Blanchot's phrase, that "art is the consciousness of unhappiness, not its compensation."[6] Blanchot cautions us against misinterpreting Nietzsche's famous line, "We have art so as not to go under on account of truth." It does not mean that art preserves us from the harshness of truth but, rather, that the abyss is the domain of art. Art's depth might be an "absence of profundity" or the possibility of a foundation, but it is also always both of those things at one and the same time and this is its essential ambiguity.[7] *The Inertia of Desire*, in the play between its precise formal niceties and its description of incontinent social irrelevance and mental hopelessness, holds that ambiguity before us.

Homage to modernity. The left panel of *Journey to the Centre of the Earth* [plate 35] has a white background crossed by a number of coloured lines. The paint is smeared, Richter-like, in that way that makes you want to say that the image looks out of focus at the same time as it leads you to question the applicability of such a judgement. How can paint be out of focus? Even through this visual vagueness, though, the image is immediately recognisable as the central portion of the London tube map. Probably more now than the old-style policeman's helmet, or the Routemaster bus that is all but gone from its streets, or the bright red phone boxes that are pretty well obsolete, the tube map is the most commonly recognised image of the city. This is so not least because its topological design, borrowed by transportation systems throughout the world, presents an image of the entire space of the city, rather than merely offering a symbol of it. Tyson's drawings, paintings and other works frequently make use of maps and diagrams, but this one is especially potent, deriving as it originally did from a wiring diagram.

The right panel of *Journey* … has what at first sight appears to be a jumble of imagery laid over a scrubby patchwork of painted areas, marks and dribbles. There's a bunny girl, a lighthouse, a chess piece, a laughing man in a chef's hat, a pithed frog, a looping string of gloop into which several glass marbles have been stuck, and a lot more. One recalls Tyson's earlier *Primordial Soup* works, one of which also contained a snatch of Harry Beck's famous design in its mix, but a little inspection reveals that the layout here is far from random. It is in fact a kind of rebus: the bunny girl is Warren Street station, the chess piece is King's Cross, not only because the piece is the king, but also because it signals itself as the king by the cross on its top. In a gesture whose obviousness makes it almost perversely obscurantist, the chef is Baker Street. The gloop is Marble Arch, an arch of marbles, the lighthouse, Great Portland Street, because of the lighthouse at Portland Bill on the Dorset coast, the frog, Finchley Road and Frognal, and so on. And once you see this, it is clear that the placement of each image on the canvas corresponds to their topological relationship on the tube map, which in turn approximates their actual location within the geography of the capital.

Things appear over-determined. The bunny girl for instance is a light visual pun on the word "warren," but in the association of such figures with the faded, seedy glamour of the playboy lifestyle and its related activities, it connects with Tyson's interest in gambling, number systems and patterns of randomness. ("Random is the new order," runs the tag line for Apple's shuffle, a feature that Tyson has used in *Synaesthetic Turbine*, a sculptural rendition of the emotional moods dictated by three iPods.[8]) It also provides a temporal marker, locating the work in 2005 Britain, in that the somewhat outmoded symbol of the Hefner empire has recently re-entered the visual mix of British cultural life in a quite different guise. You can now buy notebooks, pencil cases and other items of school stationery all bearing the bunny logo, demonstrating that in much the same way that the formerly posh and exclusive Burberry plaid has now become ubiquitously visible on all manner of down-market accessories, the logo that once spoke of the questionable freedoms of the decidedly single adult male has now entered the fluffy desire space of the pre-pubescent girl. The sign detaches itself from its referent and floats free, waiting to be fished out and reapplied in some other context. Such a process echoes one of the chief features of the *Geno Pheno* series in that the relation between generative genotype and generated phenotype quickly ceases to be one of dependence. There is no hierarchy or order of significance, no priority—either temporal or semantic—of one element over another. As soon as the phenotype is generated

as an expression of the information contained in the genotype, it asserts its autonomous existence, folding back onto its generator in such a way as to render uncertain the relative status of the two.

We might have expected a man in a deerstalker hat with a Meerschaum pipe to do duty for Baker Street, as indeed he does on the tiles that decorate the platforms of the actual station, but Sherlock Holmes was a detective, not a baker, so his presence would skew the method of associative word-play that is in use in the work as a whole. While the final piece may end up looking highly complex, this is not as the outcome of a hugely differentiated set of decision-making procedures. Within each work, the generative method involved is always quite straightforward. *Fractal Dice No. 1* [plate 24], for example, is an almost impossibly complicated object, a feverish concatenation of rectilinear forms resembling the aftermath of a protracted session of play with a box of oversize nursery building blocks designed by members of De Stijl. In fact it is generated by rolling a normal dice and applying a simple formula regarding how much its surfaces should project or indent according to which numbers are showing on the five visible faces. The resulting form is then "rolled" again and the formula reapplied. The final piece is arrived at after only three rolls of the dice, and this underlying simplicity of procedure strengthens the appropriateness of the *Geno Pheno* nomenclature.

John Gribbin explains that the common habit of referring to DNA as a "blueprint" for the making of the human body is rather misleading. A blueprint gives detailed information on every individual part of a complex machine or structure, whereas DNA works quite differently. The better analogy, Gribbin suggests, is with something like a recipe:

> The recipe for baking a cake … doesn't tell you what the final cake will look like (let alone the precise location of every raisin in the finished cake) but says "take the following ingredients, mix well and bake for this number of minutes at that temperature." Such a recipe is like one step in the chaos game. It is hard to see how even the wealth of DNA contained in a single cell that develops to become a human being, or a pine tree or whatever, can contain a literal blueprint for all the complex structures involved in the final adult form. But it is much easier to see how that DNA might contain a few simple instructions along the lines of "double in size for *n* steps, then divide in two, and repeat in each branch."[9]

A further joke with *Journey …* is that there is already a very well known link between the tube map and contemporary art. One of Tate's best selling lines is the poster of Simon Patterson's *Great Bear*, a reproduction of the "Journey Planner" map found on every platform throughout the Underground network but with all the station names changed. While this would not have formed any part of the thinking during the making of *Journey to the Centre of the Earth*, the connection is, once again, one that Tyson is happy to recognise as an element contributing to the work's context. We should not doubt, either, that Tyson is aware of conceptualist works such as Daniel Buren's contribution to the "18 Paris IV 70" exhibition, in which he pasted a blue and white striped poster in the upper right hand corner of the entertainments information billboard in each Métro station. Buren's text accompanying the photographic documentation of this work reads in part:

> These pasted pieces of striped paper were and still must be considered as part of a work which began, was carried on and is still in process outside and beyond the place and time of this particular proposal. The

photo-album is here a partial re-presentation of the work as it stands, each individual presentation being unique but always considered as a fragment of the entire work as it stands.[10]

In other words, the work is not an object, but a process unfolding through time. Just as Wittgenstein rejects the idea that a system of thought is a point of departure from which one proceeds towards the outcome of a verifiable proposition, the work should not be seen as the realisation of an abstract idea. In Deleuzian terms it is, instead, a case of a potentiality, which is virtual, being actualised. It is never a case of something's becoming real since both the virtual and the actual are part of reality. As Manuel DeLanda puts it, "the virtual leaves behind traces of itself in the intensive processes it animates."[11] Tyson's *Geno Pheno* works are just such traces.

□ □ □ □ □ □ □

Forwards and backwards. In *My Mum, My Son, and the Space Between the Sea and the Sky* [plate 43] a little boy peers through a knot hole in a wooden fence. We cannot see what he is looking at, but on the gallery wall his line of sight leads us to the adjacent canvas on which is painted a reproduction of a black and white photograph of a woman reclining on a hillside. The style of her dress and hat, the implied quality and colour tone of the photograph, and the fact that it is a black and white image, place it somewhere around the late 1950s or early 1960s. It is indeed a photo of Tyson's mother when she was young. The boy looks at his grandmother across a narrow gap in which Tyson himself invisibly resides, both as a link in the genetic chain binding the two figures together, and as the artist-ringmaster marshalling his performers to do his bidding. Yet this position is far from being a comfortable one if we admit that the photograph is, in Barthes' words, a "distortion between certainty and oblivion" that brings a "detective anguish"[12]: "All those young photographers who are at work in the world, determined upon the capture of actuality, do not know that they are agents of Death ... *Life/Death*: the paradigm is reduced to a simple click, the one separating the initial pose from the final print."[13] The pairing of grandson and grandmother reminds us with a shudder that the space of the title, which of course in some important sense does not actually exist, is always already prefigured, even for a child. It can never be Rilke's "Open," that space which lies outside and in front of all creatures except ourselves. We are condemned to approach the future while forever looking backwards:

All eyes, the creatures of the World look out
into the open. But our human eyes,
as if turned right around and glaring in,
encircle them; prohibiting their passing.
What lies outside, their faces plainly show us.
Yet we compel even our youngest; force
each child always to stare behind, at what's
already manifest, and not to see
that openness which lies so deep within
the gaze of animals. Death leaves beasts free.
Only we foreknow it. ...[14]

12

In his commentary on how Heidegger takes Rilke's notion of the "Open" and turns it to his own purposes, Giorgio Agamben remarks that the philosopher was perhaps "the last to believe … that the anthropological machine, which each time decides upon and recomposes the conflict between man and animal, between the open and the not-open, could still produce history and destiny for a people."[15] But as Walter Benjamin had already recognised, whereas man's development as a species may well have been accomplished some thousands of years ago, mankind's was still only just beginning:

> In technology a *physis* is being organised through which mankind's contact with the cosmos takes a new and different form from that which it had in nations and families. One need recall only the experience of velocities by virtue of which mankind is now preparing to embark on incalculable journeys into the interior of time, to encounter there rhythms from which the sick shall draw strength as they did earlier on high mountains or on the shores of southern seas.[16]

We have been used to thinking of what we grandly term "nature" as what there is within and around us that needs dissecting and explaining, but this is too restricted a view of what awaits examination.

Covert Polyhedron [plate 16] seems a misnomer, since what is presumably the eponymous polyhedral form sits openly on top of its steel plinth. But where it is "covert" is in the plinth, the genotype. A number of points were randomly marked on the surfaces of this plinth, measurements of their positions were taken, and used as the angles in a notional geometrical figure contained "within" the plinth that would join them all up. This is a high-tech piece of work and will have required the use of computer software in order to model the co-ordinates of the polyhedron needed to instruct the fabricators. Nonetheless, it is plainly conscious of its affinity with the captives Michelangelo began to carve for one of his versions of Pope Julius II's tomb, and which remain partially held within their marble blocks in the Florence Academia. It knows of Richard Serra's work, and of Ulrich Rückriem's two-part stone pieces, one part left rough from the quarry, the other dressed to reveal the optimum smooth slab available within the dimensions of the block. It is aware, too, of the geometric sculptures of Tony Smith, and especially of his 6' x 6' x 6' *Die* that has become a key work in the history of minimalism.

In their writings about what we now call minimalism both Robert Morris and Michael Fried referred to *Die* and to Smith's contention that in making it the size it is he was consciously avoiding any chance of it becoming either a monument or an object. "One way of describing what Smith was making might be something like a surrogate person—that is, a kind of *statue*," wrote Fried.[17] *Die* does not sit directly on the ground, but is raised slightly above it, so that it is understood to be a sculptural form, not a plinth. Smith thought a purely abstract form to be unachievable since reference, association and allusion of some kind is always unavoidable.[18] As Smith's intentions for the sculpture indicate, it is quite reasonable for us to see Leonardo da Vinci's Vitruvian Man contained within the cube's dimensions. And such an idea seems even more appropriate if we also recall that in 1966 Smith had an exhibition at the Wadsworth Atheneum. There was a pool in the exhibition space in which was set a sculpture of *Venus Attended by a Nymph and a Satyr*. Since this could not be moved, he made *Fixture*, a grey-painted wooden sculpture conceived specifically to cover this feature.[19]

Following this train of associations should make clear that the geno pheno pairing is itself far from simple in relation to any one work. For sure, the polyhedron is a form containable within the cuboid volume of the plinth, and is indicated as being so by the points marked on the plinth's surfaces; but it can now be seen that it makes as much sense to think of minimalism as the genotype, the set of coded information that finds its subsequent expression in the work of succeeding artists including Tyson. And that the expression in the phenotype cannot be predetermined is shown by the fact that in *Covert Polyhedron* Tyson has revisited something like Tucker's "internal, sculptural form."

Both canvases of *Dick Dastardly's D.N.A.* [plate 19] are filled with horizontal lines of paint squeezed from the tube. They are, as near as this might be achievable by such a crude method, mirror images of one another. Is it a mitotic image, or a meiotic one? Is it one art work dividing to form two art works, or is it art work as stem cell, dividing its chromosomal pairs to leave two gametes? And what is the genealogical line to follow: the artistic one—Richter again, this time crossed with Morris Louis perhaps, and with a meditation on Barnett Newman's efforts to defeat symmetry—or the cartoon one? Dick Dastardly first appeared in the 1967 *Wacky Races* cartoon series, always attempting to triumph by thwarting his adversaries' ambition of winning the bizarre road race in which they were all entered.[20] Endlessly unsuccessful, his sidekick Muttley remained perversely faithful to him and yet gleeful at his repeated failure. The following year he and Muttley appeared in their own spin-off cartoon, this time as the leaders of a nefarious squadron of flyers out to nobble a carrier pigeon. Where *Wacky Races* had been inspired by the 1965 Jack Lemmon/Tony Curtis/Natalie Wood film, *The Great Race*, Dastardly's own series drew its scenario from another slapstick ensemble piece from the same year, *Those Magnificent Men in Their Flying Machines*, whose ne'er-do-well was played by the greatest of all British comedy film cads, Terry-Thomas. (Dastardly is, as it happens, a dead ringer for Terry-Thomas.) A year later still, in 1969, another character from the *Wacky Races*, Penelope Pitstop, got her own series, *The Perils of Penelope Pitstop*. As both the title and the drawing style of the cartoon made plain, this time the model was silent film's *The Perils of Pauline*. The gene line stretches in both directions, though this two-way traffic cannot be mapped simply onto historical time, since Blake Edwards' *The Great Race* was itself a homage to silent film slapstick. Forwards and backwards.

□ □ □ □ □ □ □

Tragic yearning. To the right is a faithful copy of a canvas showing the head, shoulders and upper torso of an old, bearded man. His eyes are closed, but his pose is alert so one supposes that he is blind rather than asleep. The composition is dreadful. His hat fills the entire upper half of the canvas, and its underside is painted so indistinctly that it appears to hover in a completely different space to that occupied by the figure below. His head sits too frontally for the orientation of the hat, but there's no suspicion that this has been done deliberately, in the manner, say, of the perspectival disjunctions in Picasso's immediately pre-cubist portraits of himself and Gertrude Stein. The man's left arm is bent, allowing his hand to appear at the bottom of the canvas, but this hand is badly out of proportion and far too small for the rest of the figure. It is as if the artist began at the top and found himself constantly having to revise the scale of things as he worked down the canvas. A further incongruity is that, minuscule though it is, the old man's hand has six fingers. Is this an accurate rendition from the life, or is it yet more evidence of the incompetence of the

painter, a man so engrossed in what he is doing that he is unable to concentrate? (I am saying he, conscious of the possibility that I may be mistaken.) Sometimes, we know, this can work, as in David Hockney's 1961 *Tea Painting in an Illusionistic Style*, a shaped canvas bearing a picture of a Ty-Phoo tea packet on whose side he has distractedly painted TAE. In the case of *The Six Fingered Salute* [plate 3] we are faced with a choice between options, neither of which is terribly flattering. Either the artist made a mistake, or the sitter really did have an extra digit on his left hand. If the latter is true, then the attempt to capture and give due weight to this feature has been unsuccessful since it is so squashed and under-size.

To the left of the old man, the geno panel carries the text of a story. We can only read the beginning and conclusion due to a large black splodge in the rough shape of a comic strip speech bubble that covers much of the central portion of the canvas—Sean Landers or Raymond Pettibon, perhaps, after an accident with an ink pot. Or maybe one of those letters that Yossarian was forced to censor while he malingered in hospital in a desperate attempt to avoid flying more bombing raids:

> It was a monotonous job, and Yossarian was disappointed to learn that the lives of enlisted men were only slightly more interesting than the lives of officers. After the first day he had no curiosity at all. To break the monotony he invented games. Death to all modifiers, he declared one day, and out of very letter that passed through his hands went every adverb and every adjective. ... One time he blacked out all but the salutation "Dear Mary" from a letter, and at the bottom he wrote, "I yearn for you tragically. R.O. Shipman, Chaplain, U.S. Army."[21]

In fact, though, it seems that the salient features of the tale are readable. Thirty years ago, Tyson was watching "The Antiques Roadshow" with his blind grandfather, when the expert spoke to an old woman with an apparently nondescript painting. Learning that it was worth £20,000, Tyson's grandfather got him to look at the picture of the blind old man hanging in their hallway to see if that, too, might not be worth something. Young Keith's conclusion was that it was not, not least because the man had six fingers. Though they laughed about it, the grandfather insisted that one day it really would be valuable. Now, of course, it is, because it has been copied into a work by Keith Tyson, for whose output, as we know, there is an established market.

□ □ □ □ □ □ □

Virtual and actual. A shelf full of books contains a broad selection of volumes, the great majority of which will be familiar to the viewer. Even if he or she has not yet got around to reading them all, their names will strike a chord. Taken altogether they suggest one of those lists compiled by a consultant for a client who didn't have the time to explore literature on their own, but who wanted to gain the appearance of a good understanding. There is some heavyweight stuff—*Swann's Way*, *Ulysses*, *Gravity's Rainbow*, but also some more light-hearted material—a PG Wodehouse, and even a nod towards populism in Dan Brown's *Da Vinci Code*. There are 100 books, one published in each year of the past century, and arranged in the chronological order of their issue. A hole has been cut through the centre of the books and the resulting cylinder of page fragments treated as a sort of core sample providing information on the

changing cultural nature of the century. Like a cross between an ice core and a slice through a tree trunk, whose layers and rings respectively reveal climatic and atmospheric data across a time period, the sentence fragments on the paper discs contain imagery, terminology and phrasing that is both specific to and characteristic of the moment of their production. Sparked by some of these fragments, various small sculptures hang from the shelf, their form, style and material consonant with their location within the century.

There are, of course, earlier instances of the kind of textual interpolation and manipulation that is occurring in Tyson's *A Dendrochronological Library* [plate 18]. One thinks of the chance operations of Dada, such as Tristan Tzara's recipe for writing a poem, or of William Burroughs' use of the cut-up technique, or of John Cage's mesostics. All are relevant, both as antecedents, and as the means to establishing the context within which the *Dendrochronological Library* as a whole can appear as particular to its time. The century it spans runs from 1905–2005; it is Einstein's century. 1905 saw him publishing those four path-breaking papers, on the photoelectric effect, Brownian motion, the relationship between mass and energy, and special relativity, and their implications are still being worked through. There had not been a moment of equivalent intensity in scientific discovery since 1665–6 when, staying in the countryside to avoid the plague, Isaac Newton was able to develop calculus, together with his theories of gravity and colour. Without that, we might not have been able to read some of Pynchon's deliberately cheesy jokes, such as the one Slothrop reads scratched on the cabin wall of the toilet ship *Rücksichtlos*:

$$\int \frac{1}{(cabin)} d(cabin) = \log cabin + c = houseboat \quad \text{[22]}$$

According to Gerald Howard, Pynchon is the "poet of shit," a title that might also be bestowed upon Dieter Roth or John Miller, both of whom stand in the shadows of the fracturing agglomeration of faecal brown travel mementos and toys that swamps the central glowing blue sphere of *Globe of Shit* [plate 25].[23]

At the beginning of *The Da Vinci Code* there is a page headed "Fact," which lists information about past members of a "European secret society" called The Priory of Sion. Newton, Botticelli, Hugo and da Vinci, we are told, were members. Supporting evidence for this can be found in documents known as "Les Dossiers Secrets" in the Bibliothèque Nationale in Paris. And just in case you were tempted to raise a quizzical eyebrow at any of this, the clincher is that the documents are not merely papers but "parchments." So it must be true. Then there's some stuff about Opus Dei followed by a final sentence:

All descriptions of artwork, architecture, documents and secret rituals in this novel are accurate.[24]

And this really is true, this really is fact. They are accurate because they are in the novel, which is its own world. It is, like all artworks, a "what if?" scenario.

In one of our conversations as we walk round his studio, Tyson brings up the problem of certainty by mentioning the old difficulty of defining things:

"What's a brother?"

"It's a male sibling."

"But a male sibling is a brother, so the question remains, what's a brother?"

Wittgenstein's *On Certainty* begins from a similar question, derived from G.E. Moore, as to whether one could know that something was a hand: "If you do know that *here is one hand*, we'll grant you all the rest."[25] This is not to say that one cannot derive certain statements from other propositions, but those propositions, too, will not be provable in any absolute sense. Later on Wittgenstein says this:

> All testing, all confirmation and disconfirmation of a hypothesis takes place already within a system. And this system is not a more or less arbitrary and doubtful point of departure for all our arguments: no, it belongs to the essence of what we call an argument. the system is not so much the point of departure, as the element in which arguments have their life.[26]

The interdependence of the various parts of *Solar Powered Vacuum* resonates with conceptualism's interest in systems, notably Marcel Broodthaers's formulation on the interdependence of art and theory, and Robert Morris's exercises in tautology such as *Card File*, *Metered Light Bulb* and *Box with the Sound of its own Making*. There are, however, important differences. Broodthaers's text is cyclical, implying that the system of art's production and consumption is self-contained:

> View, according to which an artistic theory will be functioning for an artistic product in the same way as the artistic product itself is functioning as advertising for the rule under which it is produced. There will be no other space than this view, according to which ...[27]

Solar Powered Vacuum, by contrast, is what might be called a complex system which, due to the fact that it draws its energy from outside, is open rather than closed. Systems of this kind operate on the edge of chaos, or "self-organised criticality," and it is this sense that things are always just as likely to be quite other than they are that remains Tyson's consuming preoccupation. In 2000, in an explicit acknowledgement of this preoccupation, he gave a work the title, *An Open Lecture about everything that was necessary to bring you and this work together at this particular time* (p. 18, fig. 2); and that so much of who we are and what we experience is unavoidably dependent on happenstance and accident sits at the heart of his thinking about and response to the world.

□ □ □ □ □ □ □

Collateral campaign. Robert Musil opens his long, unfinished novel, *The Man Without Qualities* with a chapter disconcertingly titled "Which, remarkably enough, does not get anyone anywhere." It sets the scene, and while that might more easily be achieved by use of the clause, "One fine day in the city of Vienna ...," Musil chooses to do it over several paragraphs with a more elaborate description of the interacting atmospheric factors that determine the weather conditions, and the largely incoherent jostle of rhythms, movements and vectors that make up city life.[28]

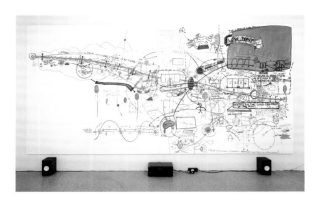

fig. 2:
*An Open Lecture about everything that was necessary to bring you
and this work together at this particular time*, 2000
mixed media, sound installation, 4 panels
overall dimensions: 96 x 192" (2440 x 4880 mm)
Soros Private Collection

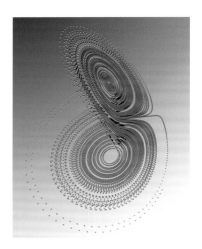

fig. 3:
Lorenz Attractor

Motor cars came shooting out of deep, narrow streets into the shallows of bright squares. Dark patches of pedestrian bustle formed into cloudy streams. Where stronger lines of speed transected their loose-woven hurrying, they clotted up—only to trickle on all the faster then and after a few ripples regain their regular pulse beat.

The Man Without Qualities was written and published years before Edward Lorenz did his work on meteorological prediction, and before the derivation of the characteristically shaped phase space attractor that bears his name, and which has cemented the popular idea of the butterfly effect (fig. 3). It also predates Benoit Mandelbrot's studies of fractal geometry and the rise of chaos theory, but the image of both the weather and the city as studies in fluid dynamics is already there in Musil's prose. In chapter 2, Ulrich, the man without qualities, observes the "flux of the street" and thinks to himself that, "it doesn't matter what one does. In a tangle of forces like this it doesn't make a scrap of difference." All the same, things do get done and do seem to make a difference, even if they don't figure again in this particular narrative. The opening chapter that does not get anyone anywhere, if it were written simply as a single sentence, might be completed: "One fine day in the city of Vienna, a pedestrian was knocked down by a truck."

–Michael Archer

ENDNOTES

The title is a series of expletives uttered by Captain Haddock in *Red Rackham's Treasure*. He has been drinking and jumps into the water without attaching the helmet to his diving suit. Much to his annoyance, though unsurprisingly, the suit fills with sea-water. Hergé, *The Adventures of Tintin: Red Rackham's Treasure*, Methuen, London, 1974, p. 43.

1. William Tucker, *The Language of Sculpture*, Thames & Hudson, London, 1974, p. 37 (his italics).

2. Gilles Deleuze, *Expressionism in Philosophy: Spinoza*, Zone Books, New York, 1992, p. 27.

3. http://en.wikipedia.org/wiki/The_Blue_Marble

4. Paul Celan, "The Meridian," in *Collected Prose*, Carcanet, Manchester, 1999, p. 46

5. ibid, p. 52

6. Maurice Blanchot, *The Space of Literature*, University of Nebraska Press, Lincoln, Nebraska, 1982, p. 75.

7. ibid, p. 239.

8. http://www.apple.com/ipodshuffle/
 Random is the new order. Welcome to a life less orderly. As official soundtrack to the random revolution, the iPod Shuffle Songs setting takes you on a unique journey through your music collection—you never know what's around the next tune. Meet your new ride. More roadster than Rolls, iPod shuffle rejects routine by serving up your favorite songs in a different order every time. Just plug iPod shuffle into your computer's USB port, let iTunes Autofill it with up to 240 songs(2) and get a new experience with every connection. The trail you run every day looks different with an iPod shuffle. Daily gridlock feels less mundane when you don't know what song will play next. iPod shuffle adds musical spontaneity to your life. Lose control. Love it.

9. John Gribbin, *Deep Simplicity: Chaos, Complexity and the Emergence of Life*, Penguin, London, 2005, pp. 89–91.

10. Daniel Buren, *Legend I*, Warehouse Publications, London, 1973. Text printed on front and back covers in English, French, German, Italian, Japanese and Spanish.

11. Manuel DeLanda, *Intensive Science and Virtual Philosophy*, Continuum, London, 2002, p. 44.

12. Roland Barthes, *Camera Lucida*, Vintage, London, 1993, p. 85.

13. ibid, p. 92.

14. Rainer Maria Rilke, "Eighth Elegy," *Duino Elegies*, translated by Stephen Cohn, Carcanet, Manchester, 1989, p. 65.

15. Giorgio Agamben, *The Open*, Stanford University Press, Stanford, CA, 2004, p. 75.

16. Walter Benjamin, "To the Planetarium," the final section of *One Way Street*, in *Selected Writings vol 1*, Belknap Press, Cambridge, MA, 1996, p. 487.

17. Michael Fried, "Art and Objecthood," in Battcock (ed), *Minimal Art: A Critical Anthology*, Berkeley: University of California, 1995, p.128

18. Susan L. Jenkins writing on Tony Smith in Ann Goldstein (ed), *A Minimal Future? Art as Object 1958–1968*, Museum of Contemporary Art, Los Angeles, 2004, p. 340.

19. Discussed in Lucy Lippard, *Tony Smith*, Thames & Hudson, London, 1972, p. 23.

20. http://www.hotink.com/wacky/

21. Joseph Heller, *Catch 22*, Vintage, London, 1994, p. 8.

22. Thomas Pynchon, *Gravity's Rainbow*, Picador, London, 1975, p. 450.

23. Gerald Howard, "Pynchon From A to V: Rocket Redux," *Bookforum*, June–Sept 2005, p. 39.

24. Dan Brown, *The Da Vinci Code*, Corgi, London, 2004, np.

25. Ludwig Wittgenstein, *On Certainty*, Blackwell, Oxford, 1975, p. 2e.

26. ibid, p. 16e.

27. Originally published in French, German and English on the front cover of *Interfunktionen*, Autumn, 1974.

28. Robert Musil, *The Man Without Qualities*, vol 1, Picador, London, 1979, pp. 3–6.

PHENO

$$t_1 \quad \begin{bmatrix} x \\ y \\ z \end{bmatrix} = \begin{bmatrix} \dfrac{(a + b \cos v)(\cos u + 3 \sin 2u)}{a} \\[4mm] \dfrac{(a + b \cos v)(\sin u + 2 \cos 3u)}{a} \\[4mm] c \cos 3u + b \sin v \end{bmatrix} \text{(RED)}$$

Curve 1

$$a = \sqrt{5 + 3 \sin u}$$

$$t_2 \quad \begin{bmatrix} x \\ y \\ z \end{bmatrix} = \begin{bmatrix} \dfrac{(a + b \cos v)(\cos u + 3(\tan 2u))}{a} \\[4mm] \dfrac{(a + b \cos v)(\sin u + 2 \cos 3u)}{a} \\[4mm] c \cos 3u + b \sin v \end{bmatrix} \text{(GREY)}$$

Curve 2

$$a = \sqrt{7 + 5 \sin 3u}$$

(tangent in X axis /mican forms in 2nd Curve.

VARIABLE PATCH:

$b = 0.3$
$c = 0.6$
$x = -4 \ldots 4$
$y = -4 \ldots 4$
$z = -4 \ldots 4$
$u = 0 \ldots 6.3$
$v = 0 \ldots 6.3$

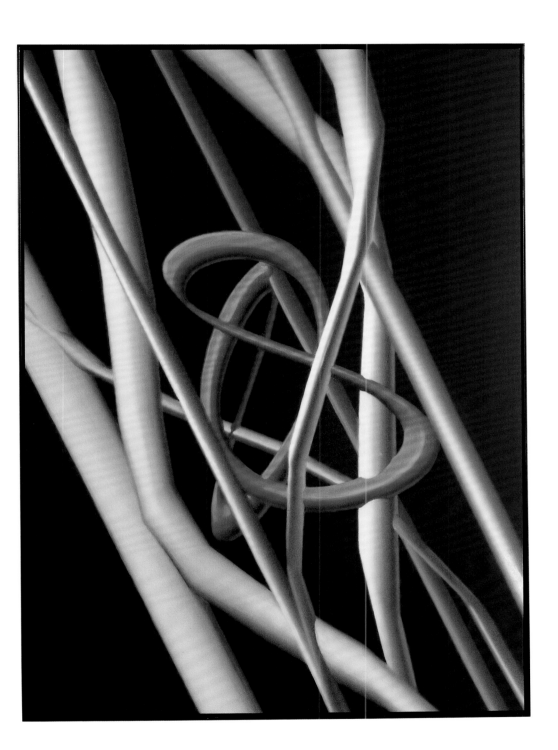

"The six fingered salute"

My grandfather was blind and I really loved him. One Sunday somewhere in the 1970's we were watching "The Antiques Roadshow" together on television. A little old lady had brought in a painting she had found to be valued. After some theatrical build-up the expert got to the main point, "Do you have the painting insured?" he asked. "No, should I?" she asked back..."Well I would certainly be looking to insure it in the region of," he paused, my grandad was smiling. "....twenty thousand pounds!" The old lady gasped and my grandad shot up out of his chair, "Quick Keith, get thyself into't passage 'ave a look if that there painting is worth owt" When I returned from the corridor

1780, hardly he's got six-fingers!" he stopped and began to laugh. After 5 minutes of uncontrollable laughing he managed to wheeze "oh Keith don't make me laugh, one day that painting will be worth something. You mark my words....."

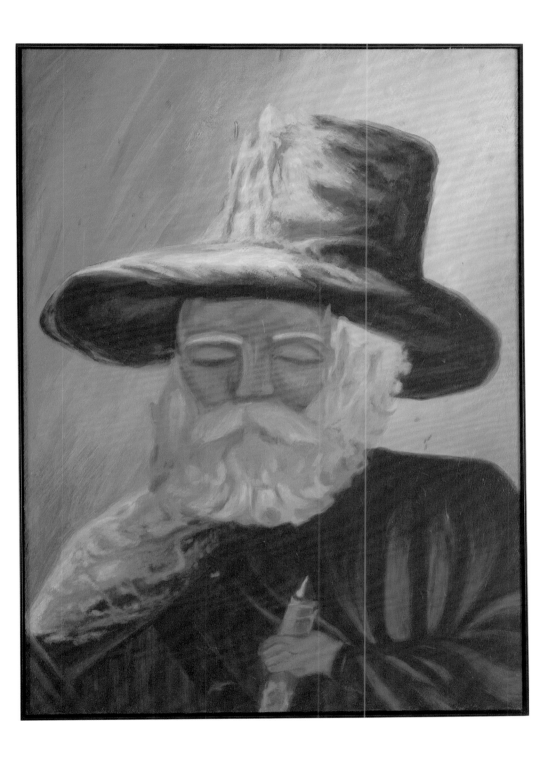

HEADS = THIRTEEN SWORDS
OVER THE RIVER
JORDAN

TAILS = SLOWLY ENTERING
THE M.R.I SCANNER

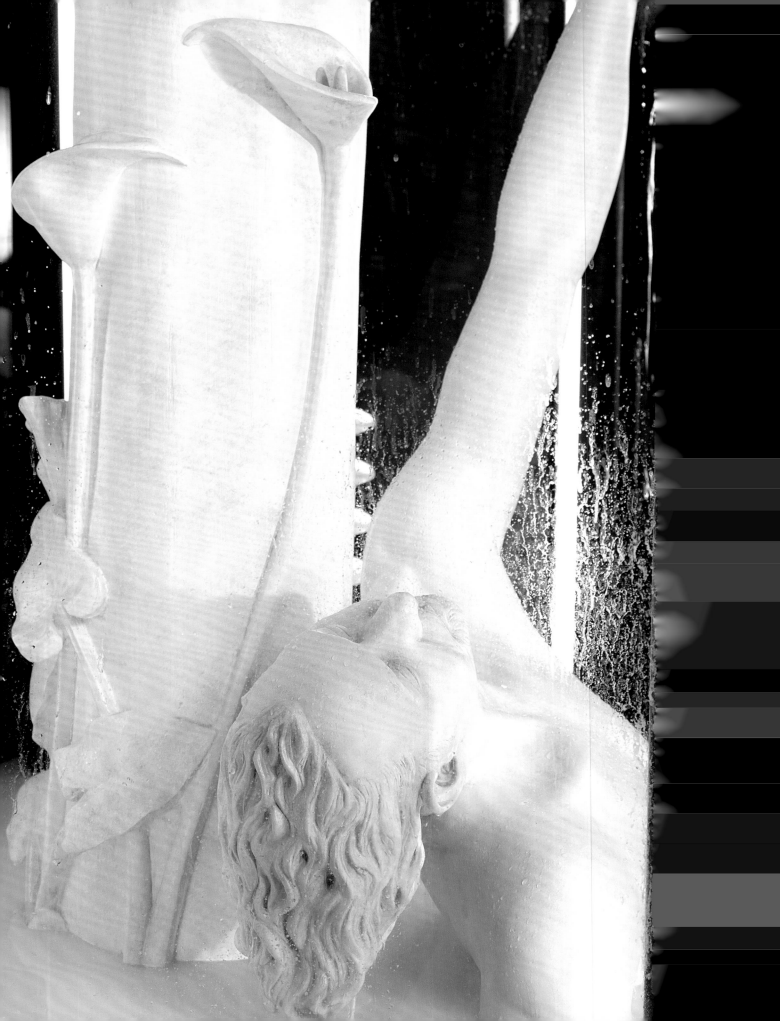

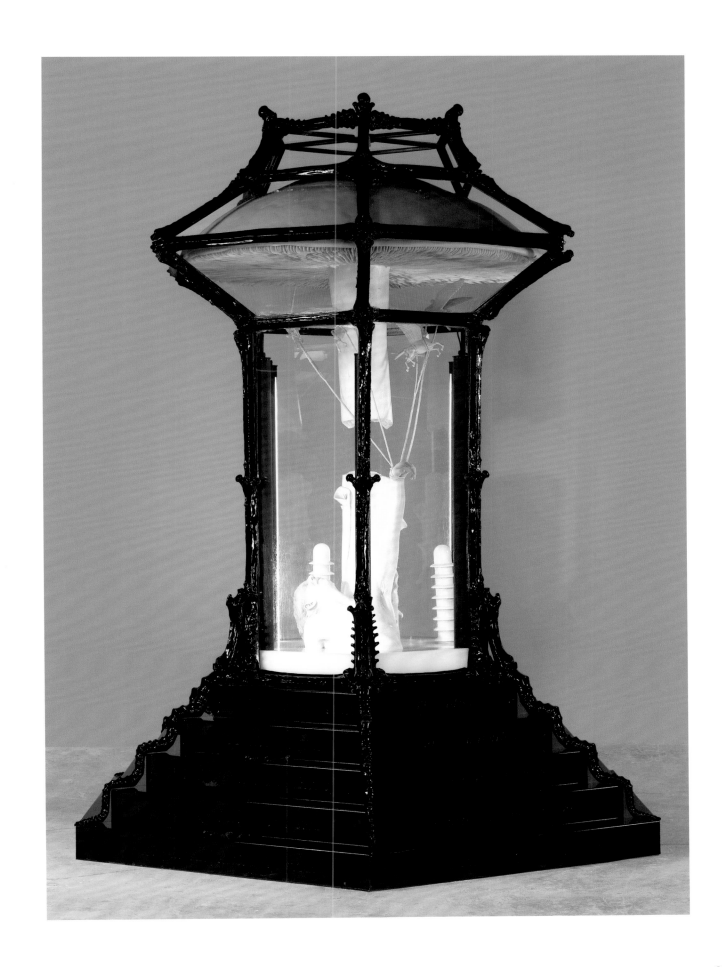

List 100 significant memories

Give each Memory an icon

Give each Icon an emotional colour

Give each Emotion a depth in time

Select 16 at random and fabricate

Shuffle and present

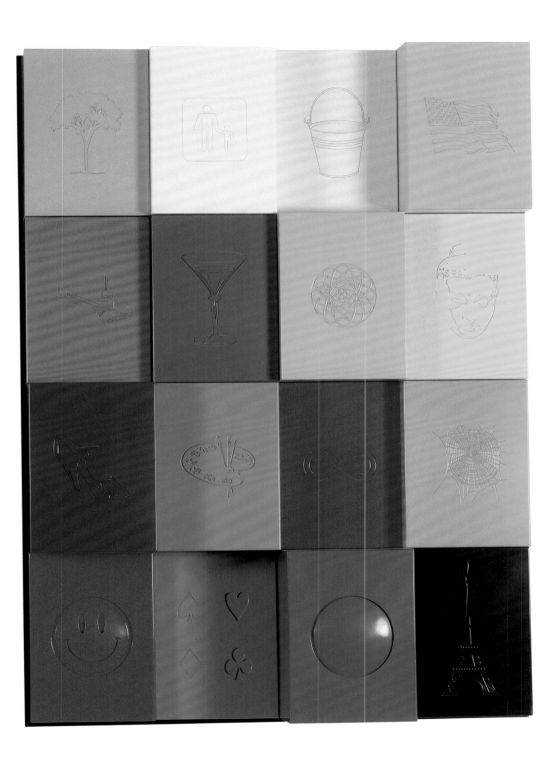

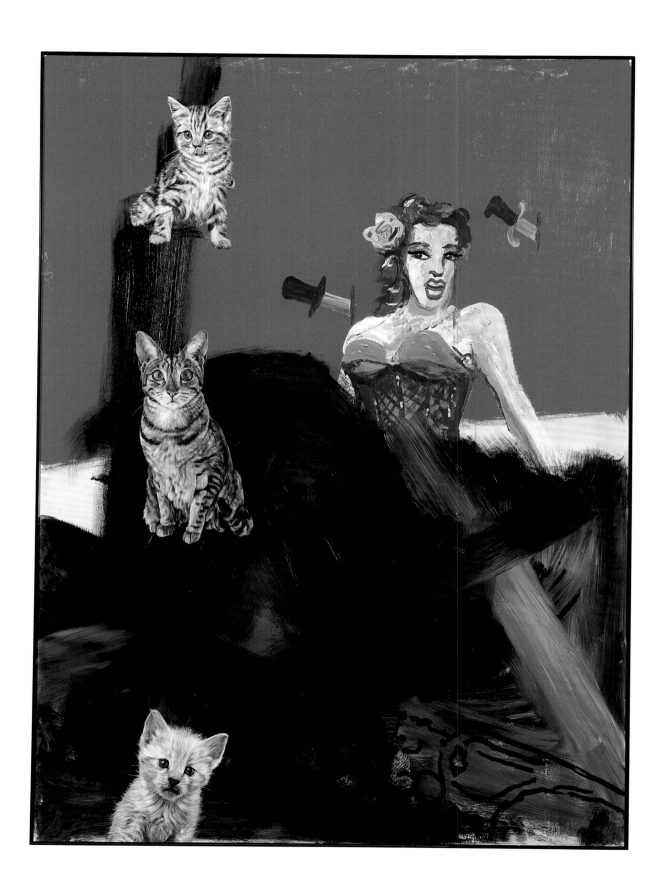

BELLADONNA

THE FIRST THING THAT I REMEMBER PAINTING WAS A TITAN BUFF CLOUDSCAPE, WHICH I DIDN'T PARTICULARLY LIKE SO I OVERPAINTED THE TOP HALF IN DEEP RED.

NOW IT SEEMED TO REQUIRE A FIGURE TO BE PAINTED OVER THE TOP

★ I DON'T KNOW WHY ★

MUCH LATER I THOUGHT THAT PERHAPS THE SPLIT COLOURS HAD REMINDED ME OF BASELITZ

ANYWAY IT JUST SEEMED LIKE THE CORRECT WAY OF LINKING THE TWO AREAS TOGETHER TO SEE WHAT HAPPENED. I SETTLED ON AN IMAGE OF A KNIFE THROWER'S ASSISTANT. AGAIN I'D HAVE TO SAY THAT I AM UNSURE OF THE REASON.

ALTHOUGH I HAD RECENTLY SEEN A FILM STARRING VANESSA PARADIS, LOOKING VERY CUTE, AS SHE SPUN AROUND AND AROUND.

I TRIED TO PAINT A WOMAN IN A KIND OF BURLESQUE/FAUX-NAIVE STYLE, ADDING LITTLE SWIRLS OF PINK FOR ROSES, IN THE END SHE LOOKED LIKE A TRANSVESTITE, RATHER THAN FIGHT THIS I ACCENTUATED THE COSMETICS TO MAKE IT LOOK INTENTIONAL BUT HER LEFT EYE DRIPPED. I'D ALSO GOT THE HIPS A BIT WRONG SO I GOT A THICK BRUSH OUT AND PAINTED THE BOTTOM HALF OUT WITH DARK GREENS, IT WAS LATE AND AS THE MUSIC PLAYED IN THE STUDIO I KIND OF GOT INTO THIS.

★ I WAS HAVING FUN ★

THERE WERE AREAS THAT REMINDED ME OF FRANZ KLEIN, KIPPENBERGER AND EVEN RICHTER. I REALLY LIKED THE LITTLE TRIANGLE OF TITAN BUFF CLOUDSCAPE STILL SHOWING THROUGH AGAINST THE GREEN STROKES AND RED GROUND AND SO RESOLVED TO PROTECT IT FROM MY FUTURE EXCITEMENTS.

NOW I DIDN'T REALLY KNOW WHAT TO DO, I LET IT GESTATE FOR A COUPLE OF DAYS

THE GENERAL PRINCIPLE WAS ALWAYS TO TAKE THE GENO/PHENO DIPTYCH AND REVERSE IT SO THAT AN INTUITIVE PAINTING WOULD BECOME THE GENERATIVE VEHICLE FOR THE MORE TEXTUAL ONE. CHANGING THE POLARITY OF PRESCRIPTIVE/DESCRIPTIVE DICHOTOMY.

TWO DAYS LATER I CAME TO THE CONCLUSION THAT THE PAINTING NEEDED TO HAVE SOME REALIST ELEMENTS. AFTER SOME THOUGHT I LOOKED FOR THE MOST PERVERSE CAT & KITTEN IMAGES I COULD FIND.

THEY WORKED WELL IN TERMS OF THEIR COLOURS BUT MORE IMPORTANTLY THEIR GAZE WAS JUST AS MANIPULATIVE BUT LESS FICTIONAL THAN THE IMPLIED VICTIMHOOD OF THE ASSISTANT

AT THAT POINT I BEGAN ANALYSING IT. (THAT THE KNIFE THROWER'S ASSISTANT LOOKED A LITTLE LIKE MY MOTHER, THAT THE MARKINGS AROUND THE KITTENS EYES MATCHED THE CHANCE DRIP FROM THE WOMAN'S.)

BUT I DECIDED NOT TO FOLLOW THESE SELF INDULGENT ROUTES AND FLED INTO THE CEREBRAL LABYRINTH OF CHANCE FOR CLOSURE WHICH EXPLAINS THE STRANGE FORM IN THE BOTTOM RIGHT CORNER

OF COURSE, ALL THE TIME I WAS PAINTING BOTH THIS PANEL I WAS AWARE THAT I WOULD BE GENERATING A SECOND ONE FROM IT, SO I DIDN'T REALLY KNOW WHAT I WAS GENERATING IT TO BE THE ORIGIN, DID NEW ANYTHING HARDLY THE ORIGIN.

A PATTERN
A PERSON
OR A PLACE

A PATTERN
A PERSON
OR A PLACE

a pattern
a person
or a place

a pattern
a person
or a place

A PATTERN
A PERSON
OR A PLACE

A PATTERN
A PERSON
OR A PLACE

A PATTERN
A PERSON
OR A PLACE

A PATTERN
A PERSON
OR A PLACE

A PATTERN
A PERSON
OR A PLACE

A PATTERN
A PERSON
OR A PLACE

a pattern
a person
or a place

a pattern
a person
or a place

a pattern
a person
or a place

a pattern
a person
or a place

A PATTERN
A PERSON
OR A PLACE

A PATTERN
A PERSON
OR A PLACE

A PATTERN
A PERSON
OR A PLACE

A PATTERN
A PERSON
OR A PLACE

A PATTERN
A PERSON
OR A PLACE

A PATTERN
A PERSON
OR A PLACE

a pattern
a person
or a place

a pattern
a person
or a place

A PATTERN
A PERSON
OR A PLACE

A PATTERN
A PERSON
OR A PLACE

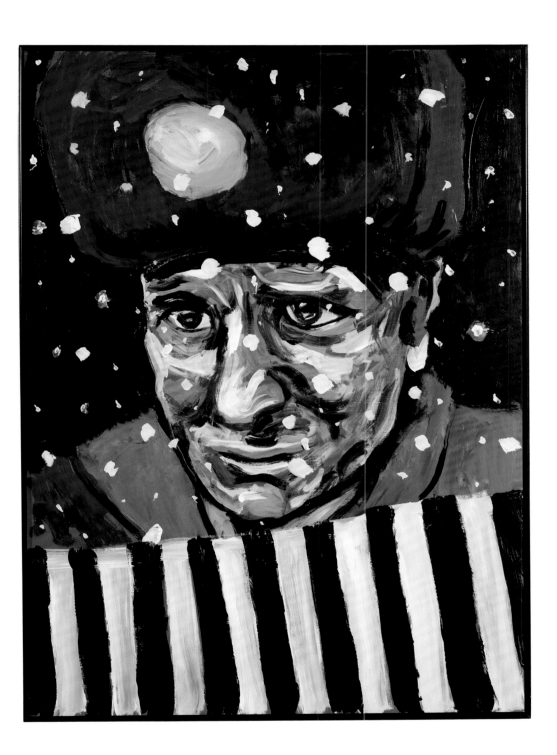

•P04 107·7

P05 299·6 •

•P/6 2·5

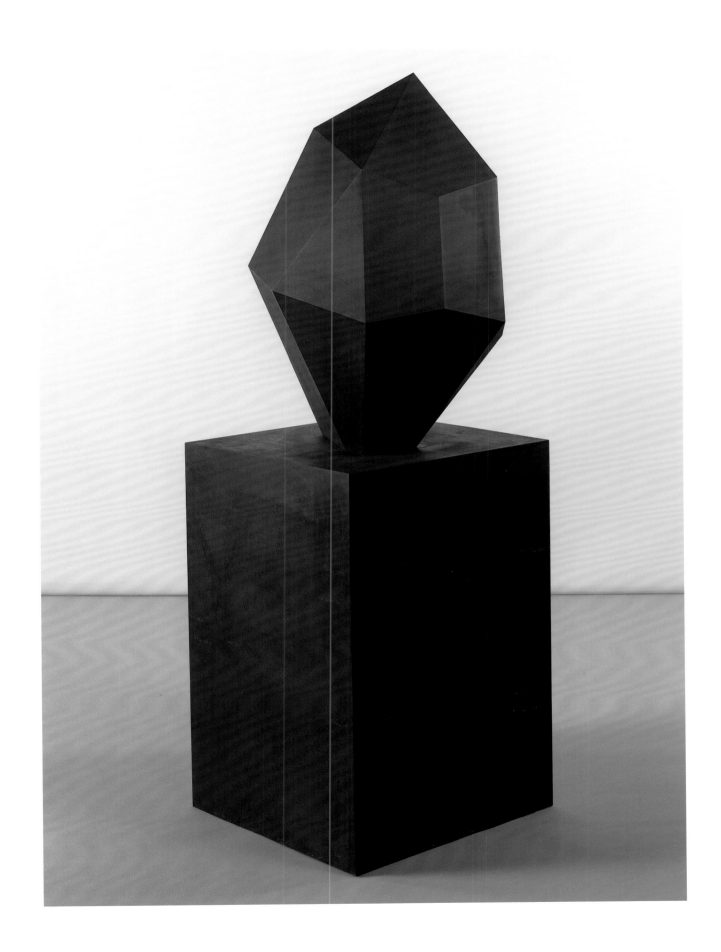

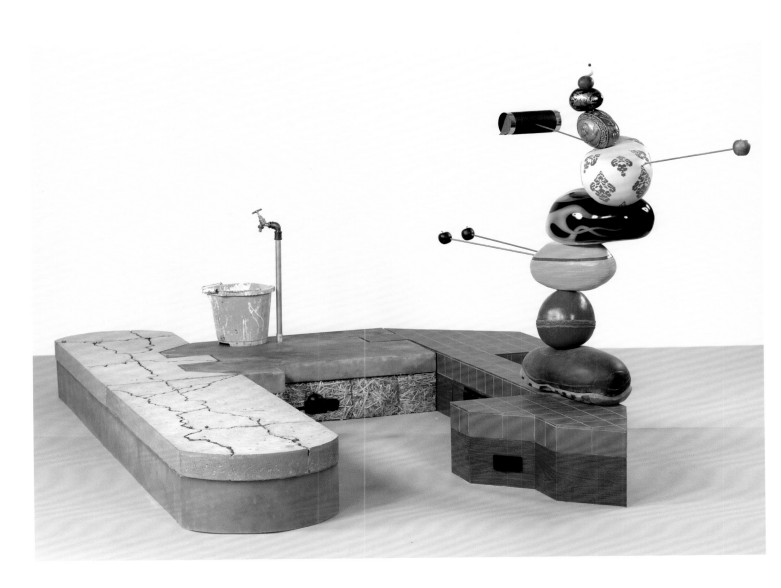

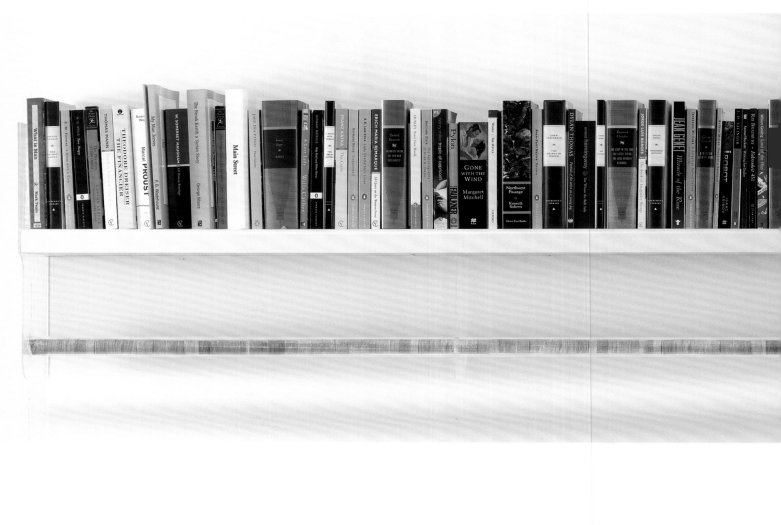

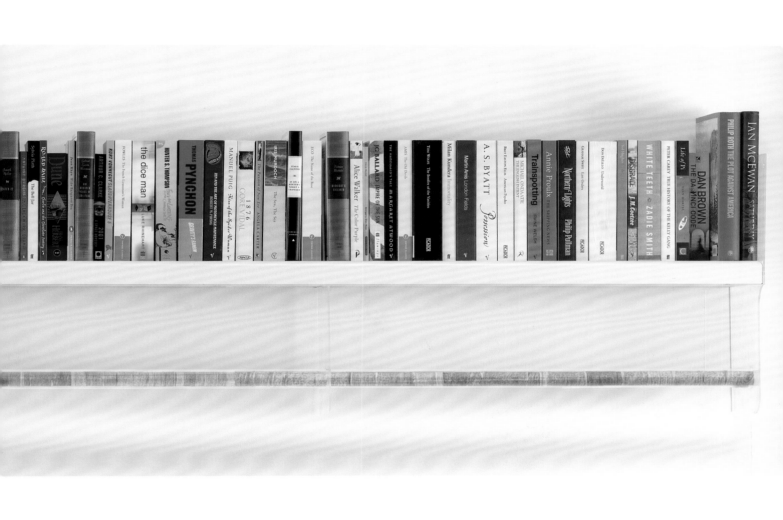

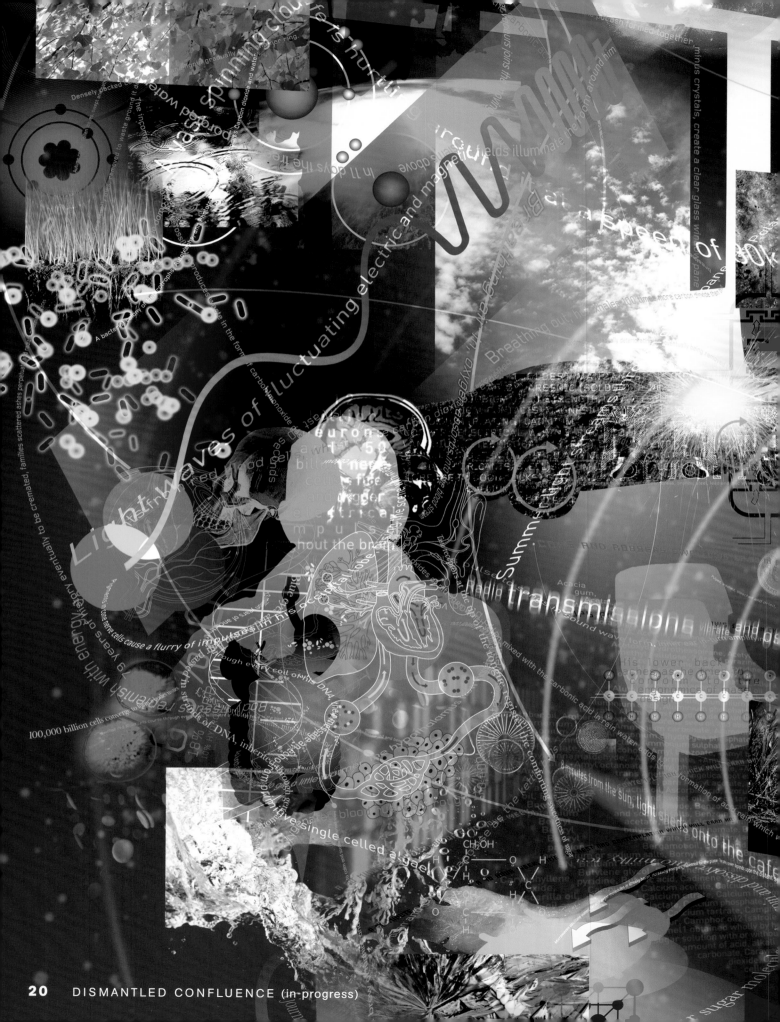

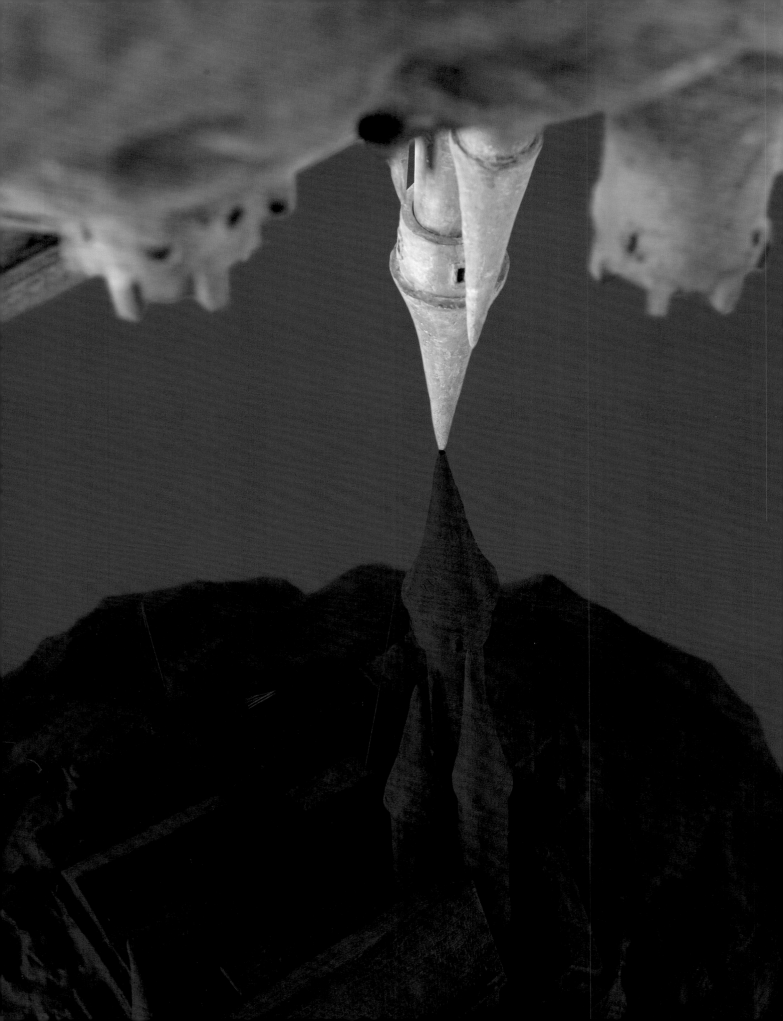

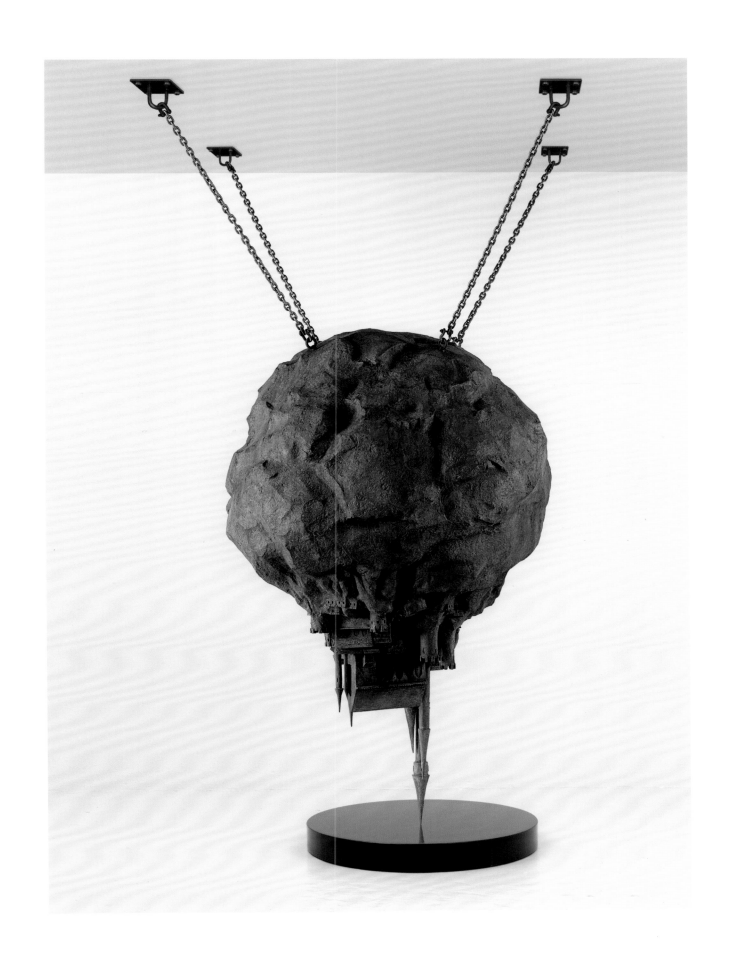

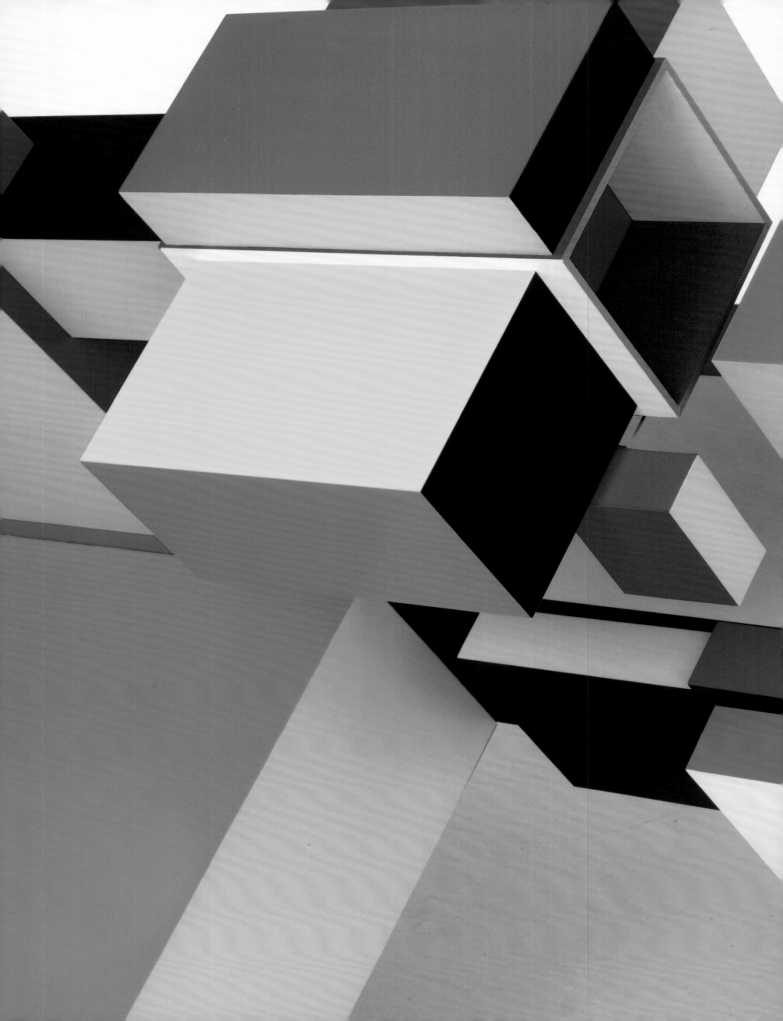

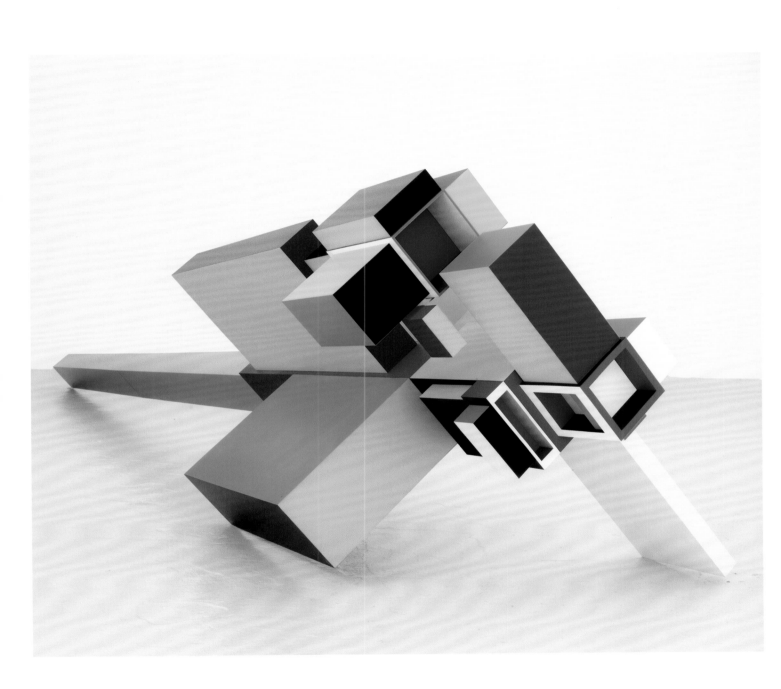

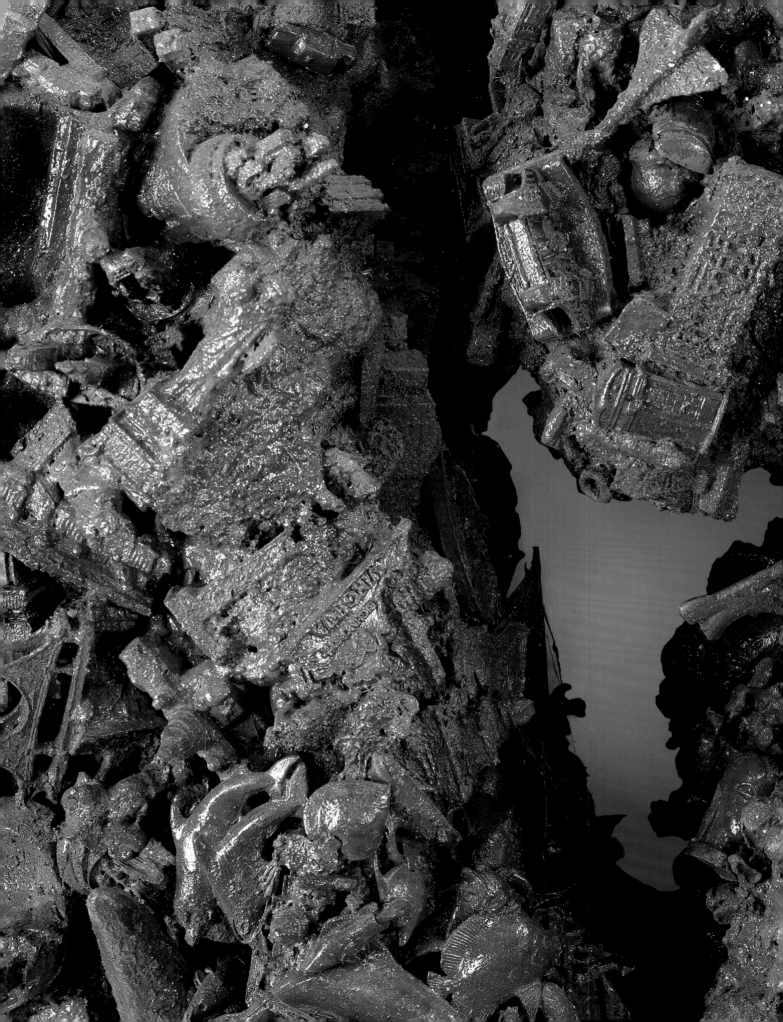

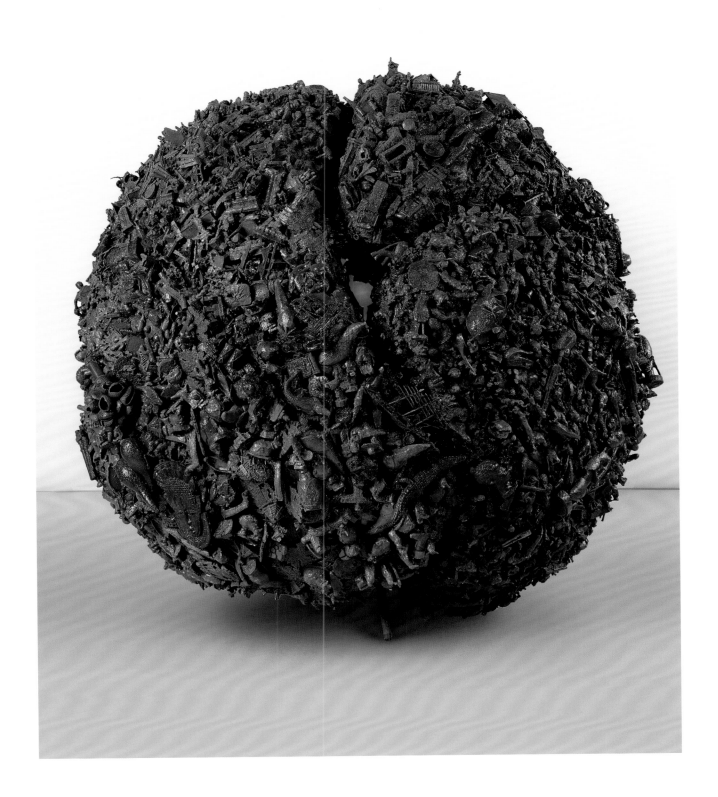

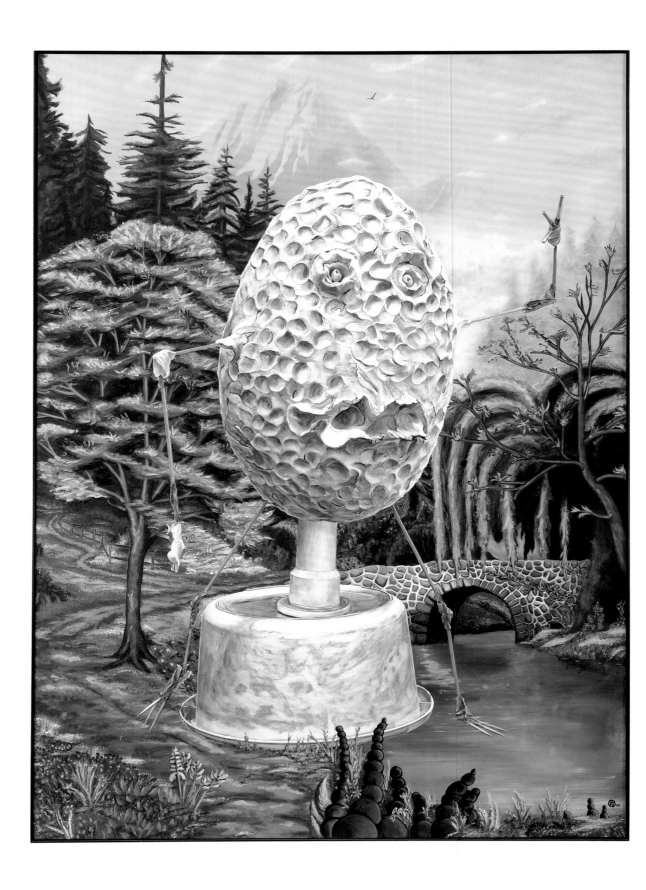

THE BIG "IT" ASTRIDE THE LURID LANDSCAPE

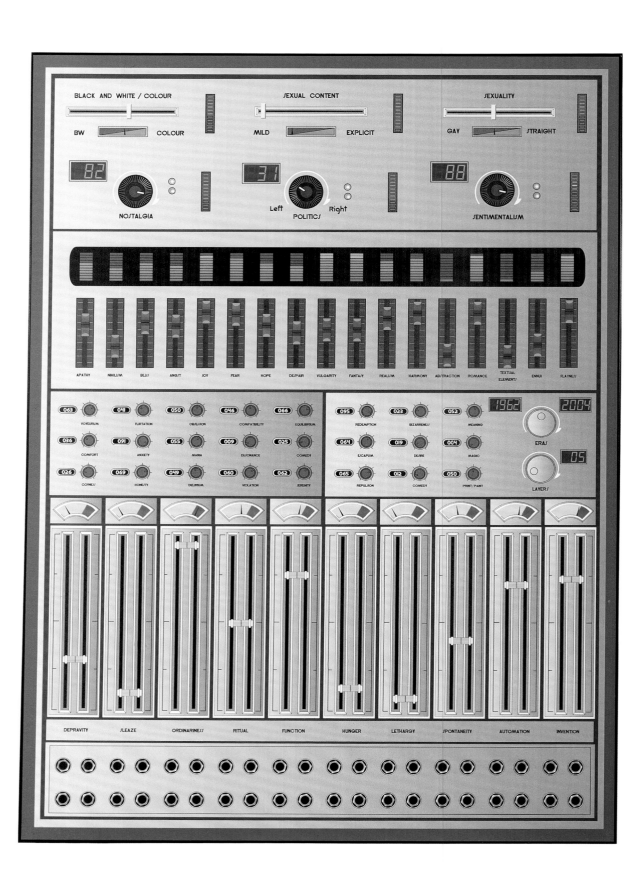

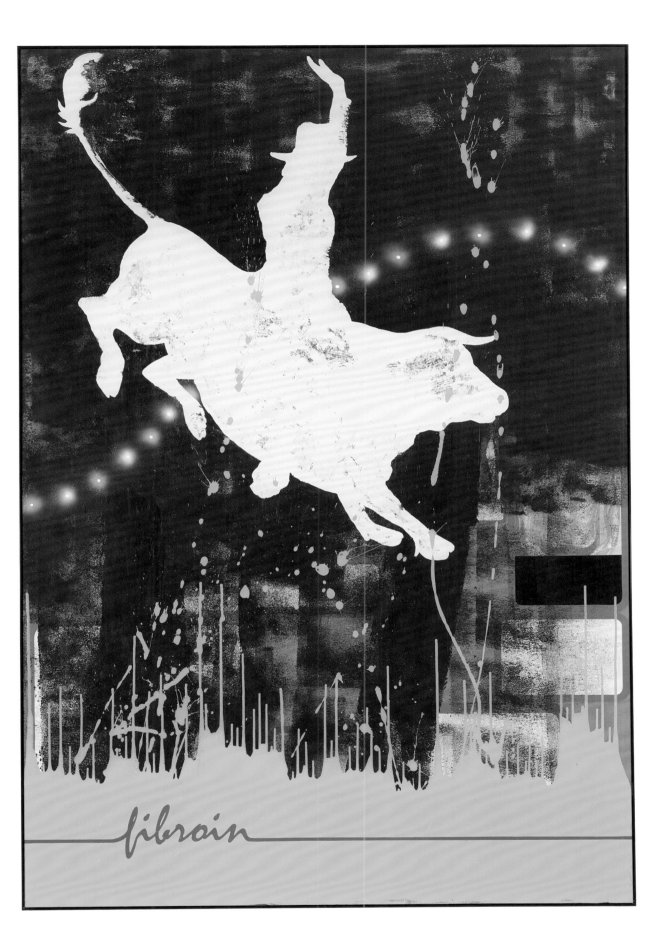

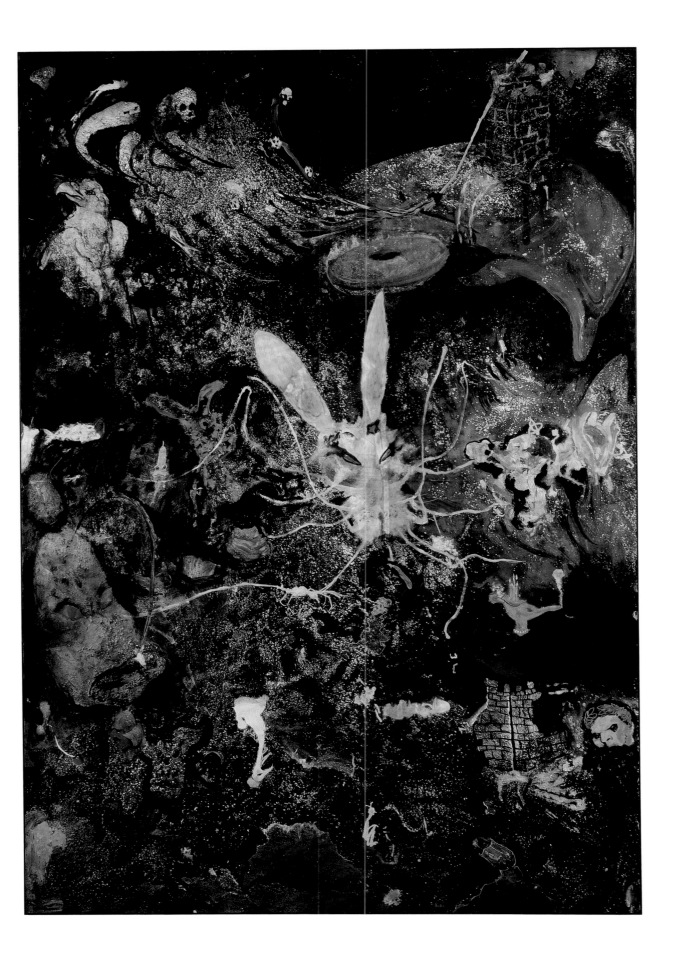

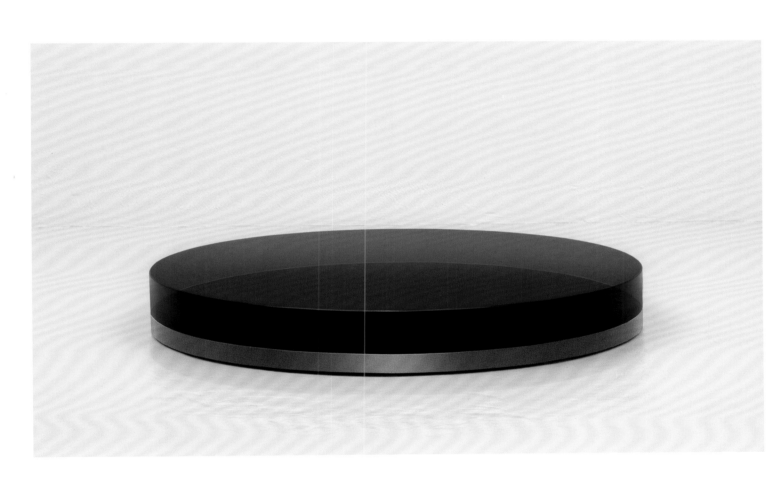

A CHANGE OF HEART
NEW YORK CITY COPS ATTEMPTING TO GET DR
THE RULE OF THUMB
ALL THE HEARTBEATS IN THE WORLD
SEED POD
A POPPY
SEEING THE WORLD THROUGH A SET OF BLUE TINTED GLASSES
AN ACTOR PLAYS A VAM
DIET COK
AN ARTMACHINE
33.07 %
H
A LECTURE BY ROY BARK
a bitter after taste
DISASTER
AN ECUMENICAL ACTION
FAUSTUS
GREEN
TRA
APHEX TWINE
A BUTTERFLY PROBOSCIS
WIMMING
HOMEMADE WINE
THE GREAT TRAIN ROBBERY
FROST CRYSTALS FOR
RES
SPORTSDAY
DU SKILLS
A GEORGE IV COIN
A LEAKING NAIL VARNISH BOTTLE
THE THRESH
E BREAD
OPEN HEART SURGERY
SILENCE ABOVE A SNOW-COVERED FOREST IN FINLAND
The 4th move
prunes
THE MIND OF A TOAD
A POOL
SUNLIGHT REFLECTED FROM GLASS
A CHRISTMAS CRACKER
75387.988
A B
FAT BILLY
BISMARK 23
SUNDAY LAWNMOWING
COOPER DIES ONSTAGE
JUDGE DREAD
AN OFFSIDE DECISION
THE DOUGH SPOON CLEAN
FLYING PAF
S 30 Kilogams of LICKING
1430203
THE WATER CONTENT OF MINAKO TAKE
GRASS TURTLE DOVES
TEENAGE SUNBATHER
Saccharin
RUBY
another insect
A GOOSEBERRY PIE
T
E TASTE OF LEMONS
A RIVERBOAT DISASTER
A LEXICOGRAPHER DEVELOPS A HEADACHE
THE NUMBER OF PUNCTURES
TRACK BAKED BEANS COOKING ON A CAMPFIRE
MANUEL DE LANDA
READING KAFKA
THE TASTE OF MURZH BOTTLED M
YAWNING REPAIRING A SHED
SEA-SPRAY LANDING
RIM
A SPINAL OPERATION
RIPE BANANAS
A PROMISSORY NOT
THE NUMBER 77333518
King's
pawn to KP4
LEIBNIZ
1980'S DANCE MUSIC
A DIRTY YELLOW
HIGH BLOOD PRESSURE
ADVERTISING JC
RLAND
LARRY LEVAN
DUSTER
A PRINTING ERROR ON A BILLBOARD
LONDON
ON 17
A GOAL SCORED IN EXTRA TIME
THE CRACKS OF E
A YELLOW PLASTIC BROOMSTICK
an itch inside an e
ANDROIDS IN A LI
METEOR SHOWER
The smell of boiling onion
THE AFRICAN VULTURE
A ME
A DRIVE-BY
AN ANT
THE DEATH OF MOHAMMED IN 622 A.D.
ST. LOUIS
Gutting a trout
A HYPERACTIVE CHILD
BOUNCES ON AN ARMCHAIR
The batsmans Holding, the bowle
ARMS OPEN
A MUGGING IN A SUBWAY STATION
A DRIPPING

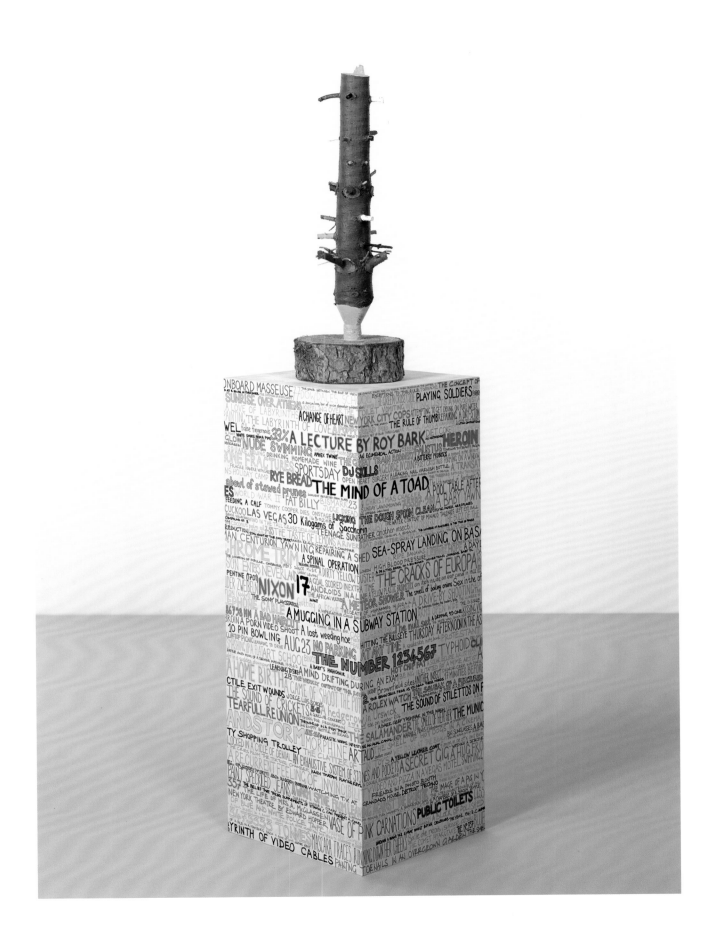

No. 23019

High wire
Rodeo
evening

9pm till
late

special
guests

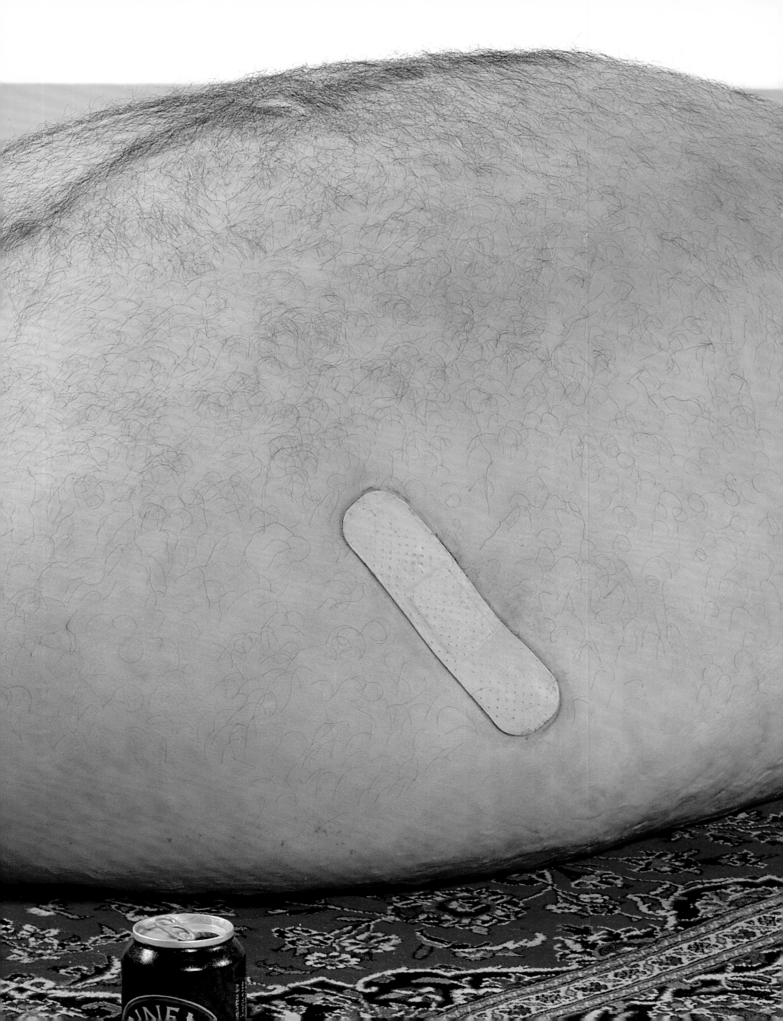

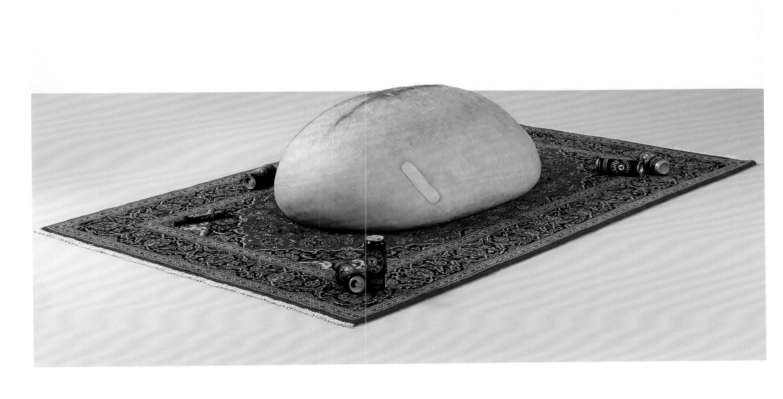

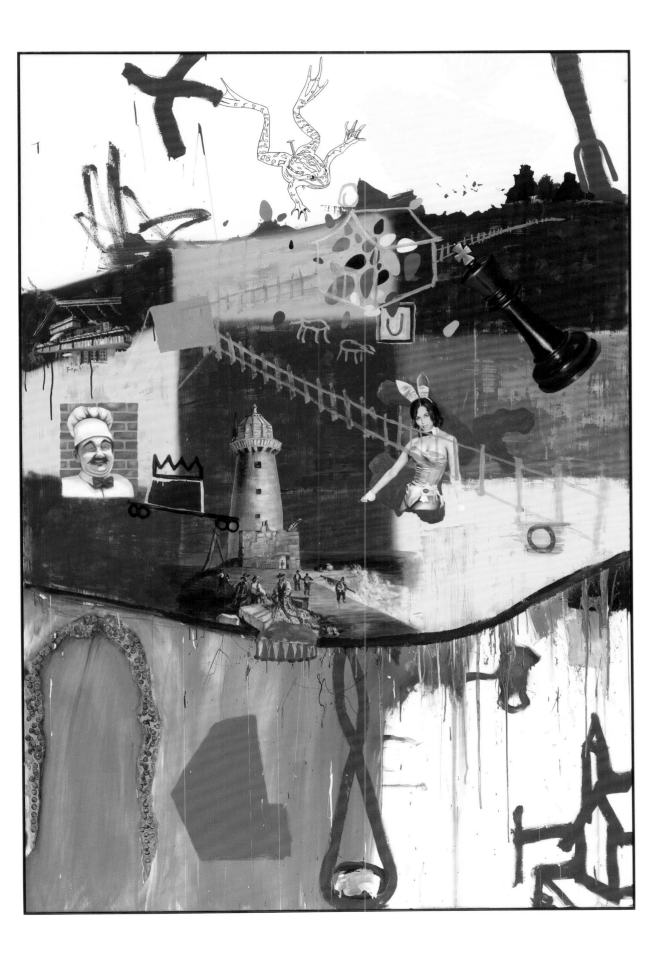

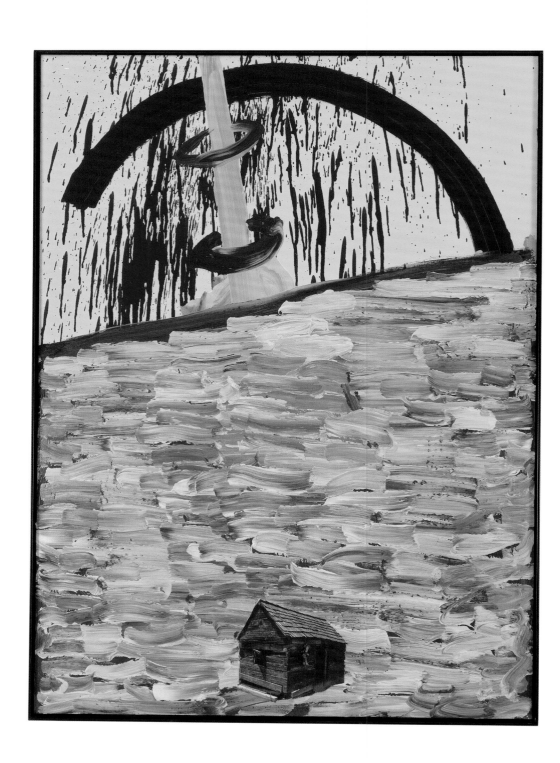

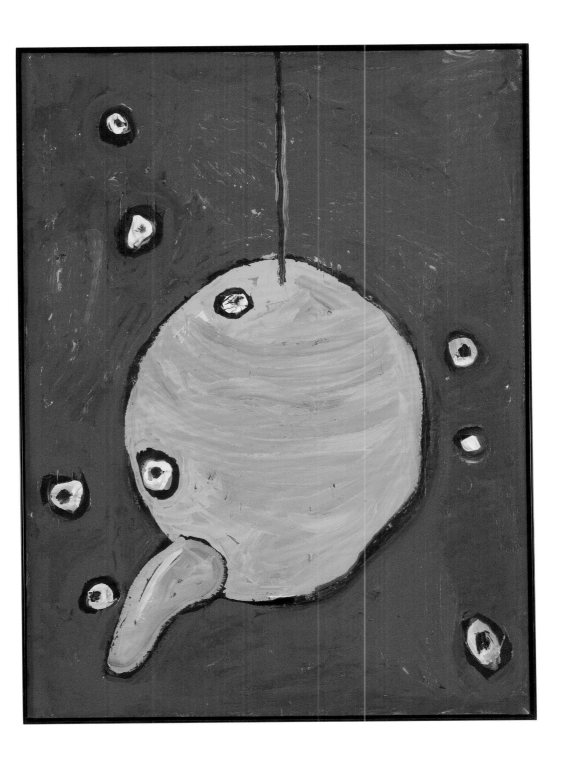

THE CORONATION OF THE MAY QUEEN
THE SNEEZE
BLING STILL LIFE WITH SWISS WATCHES
RECESSION
A 60'S PAN-AM AIR HOSTESS FETISH
TARZAN'S SECRET FANTASY
EMPLOYEE OF THE MONTH
SUNSET OVER BUILDINGS WITH SATELLITE DISHES
NO HOPE OF A CEASE FIRE
FUTURE FOOD
PINBALL WIZARDRY
BUFFALOS
PARLIAMENTARY QUESTIONS
THE FREAKS RELAX AFTER THE SHOW
SEVEN HUNDRED AND SEVENTY SEVEN INTERSECTING LINES
ALPHA MALE JANITOR
THE PRINCE
AN EMPTY WAITING ROOM
THE HYDROTECHNICAN'S SPECTACULAR VISION
EGG AND CHIPS WITH TEA OR COFFEE
AN ABANDONED TREE-HOUSE
A STAB IN THE DARK
PING-PONGING PATRIOT
THE ENGLISH HEDGEROW
DANCERS AND PRANCERS
A FORTIFIED MOUNTAIN-TOP
COLD STONE EDIFICE
I LOVED YOU
RICHARD OF YORK GAVE BATTLE IN VAIN
SUNLIGHT ON THE MARBLE
BOUNCY CASTLES
LOCKED OUT OF EDEN
ANOMALY IN THE HARDHAT AREA
A THREE WAY TRIBAL INTERSECTION
PONYTAILS AND ANKLE SOCKS
THE EXPLOSIVE POWER OF SUPER STRENGTH LAGER
MAP OF THE WORLD OF SORTS
ACORNS
TIME AND MOTION STUDIES
A BRIEF MOMENT OF LUCIDITY IN AN AIRPORT CAR PARK

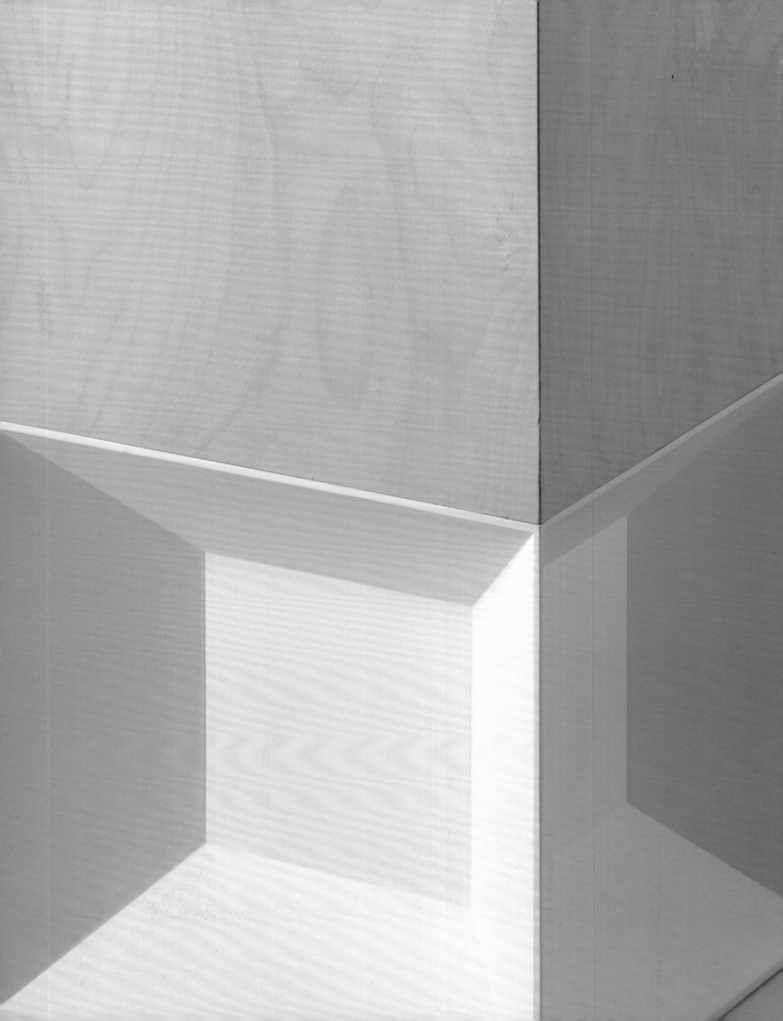

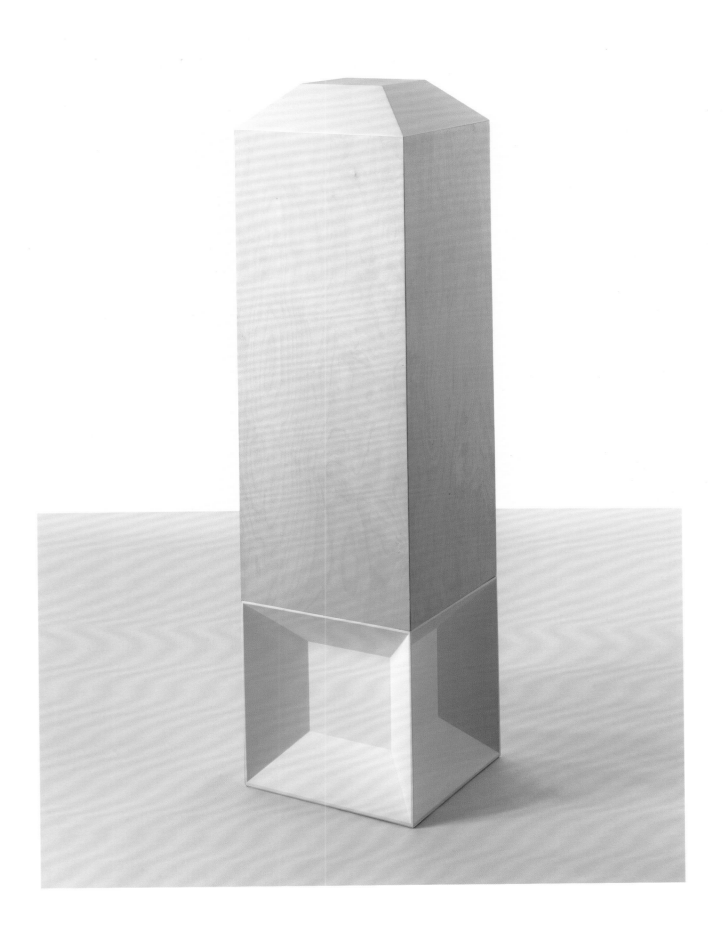

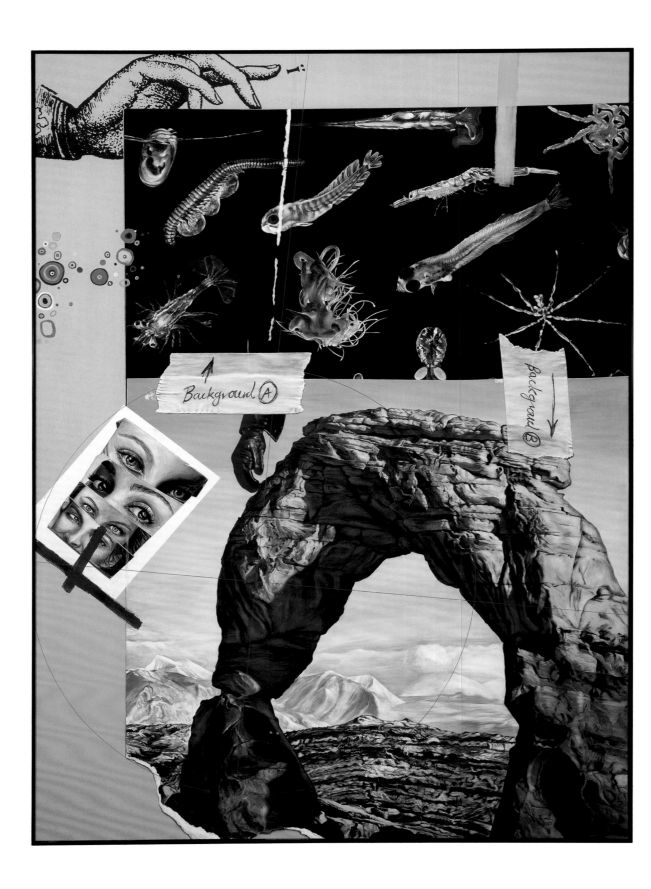

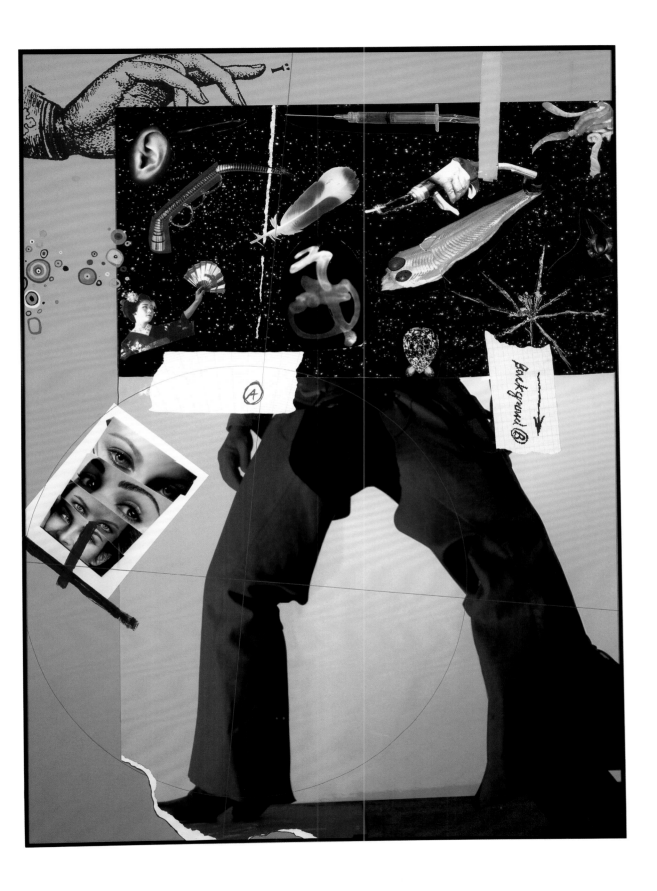

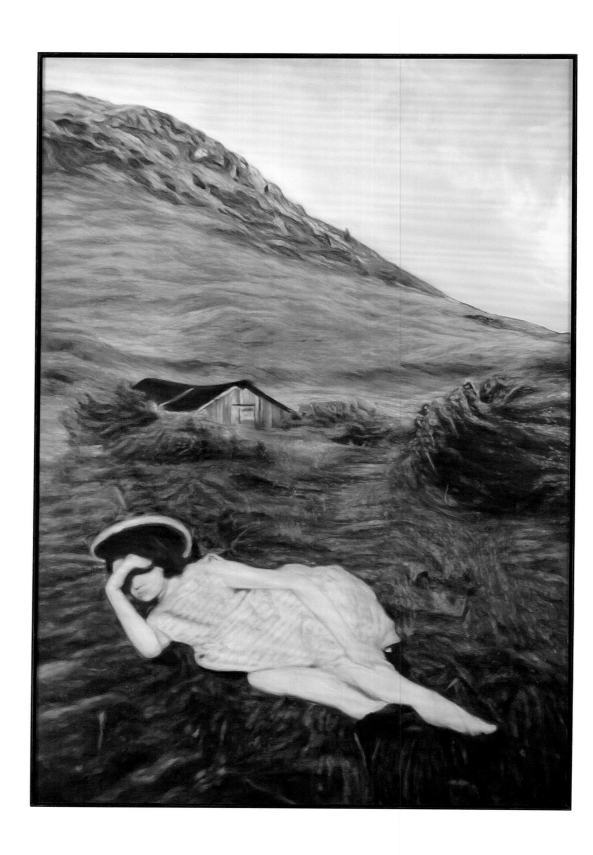

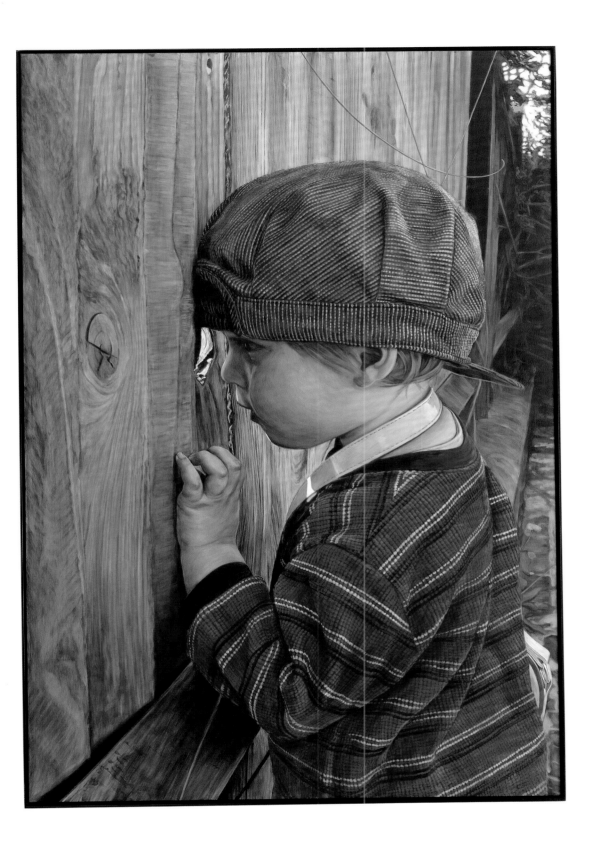

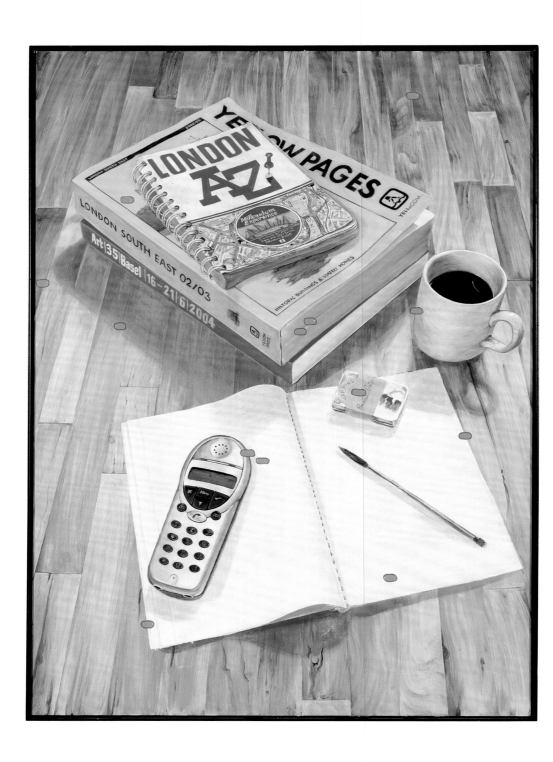

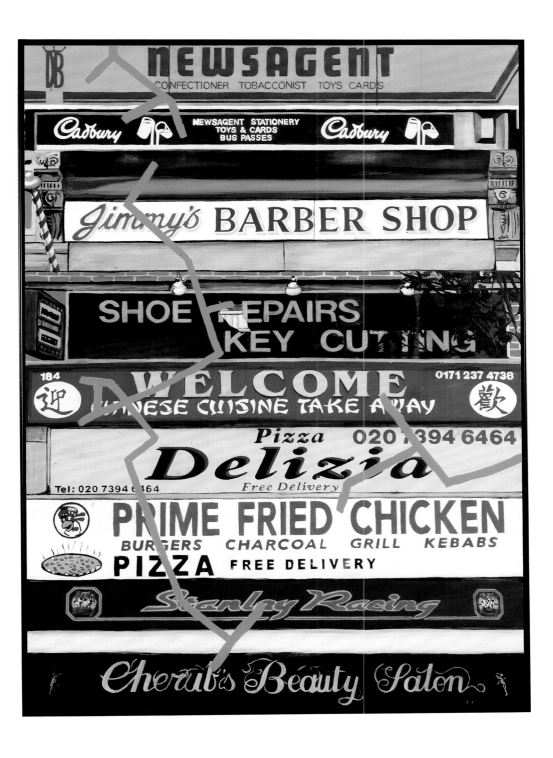

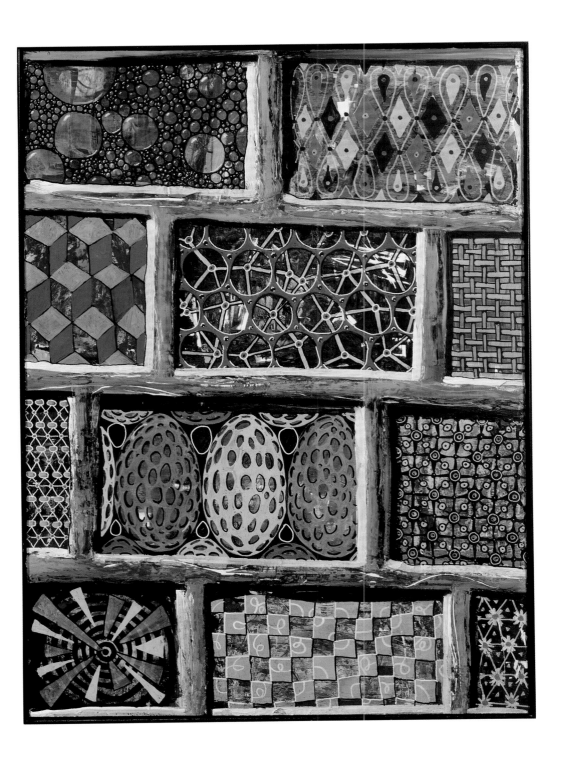

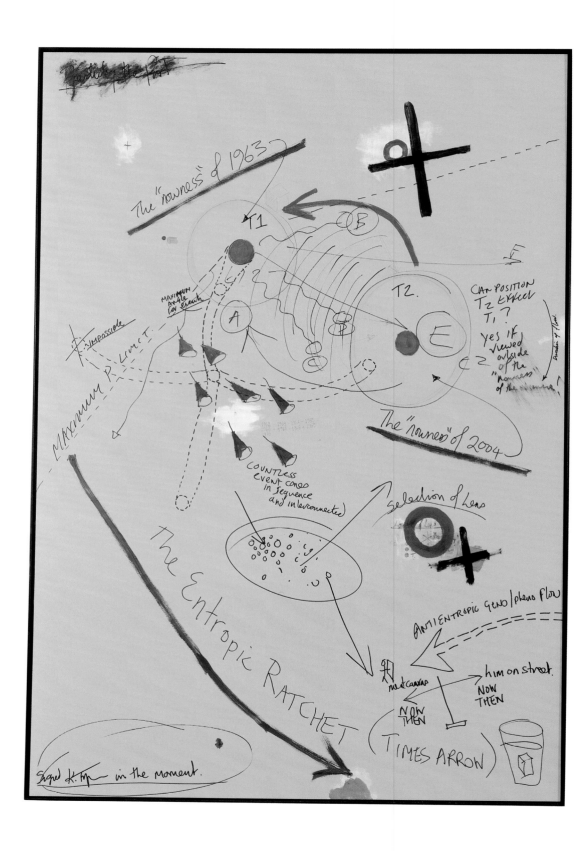

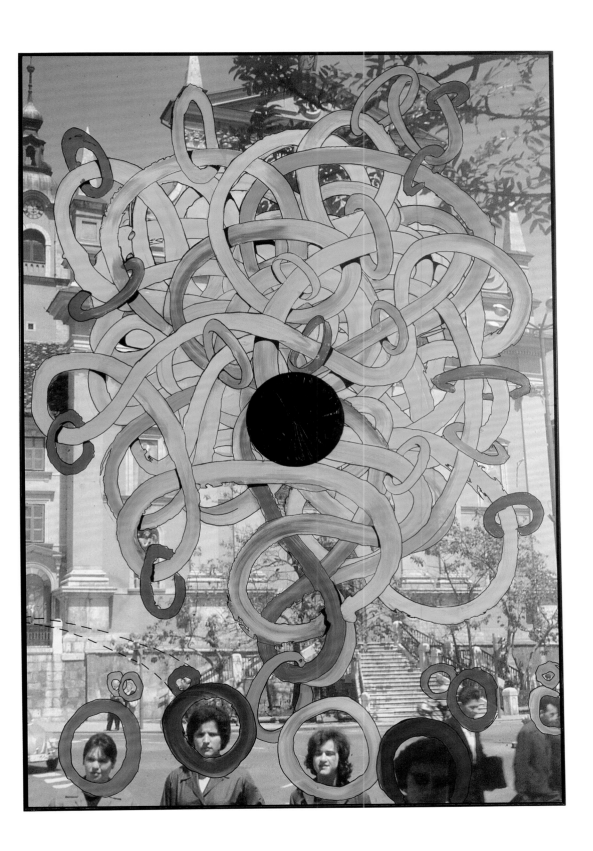

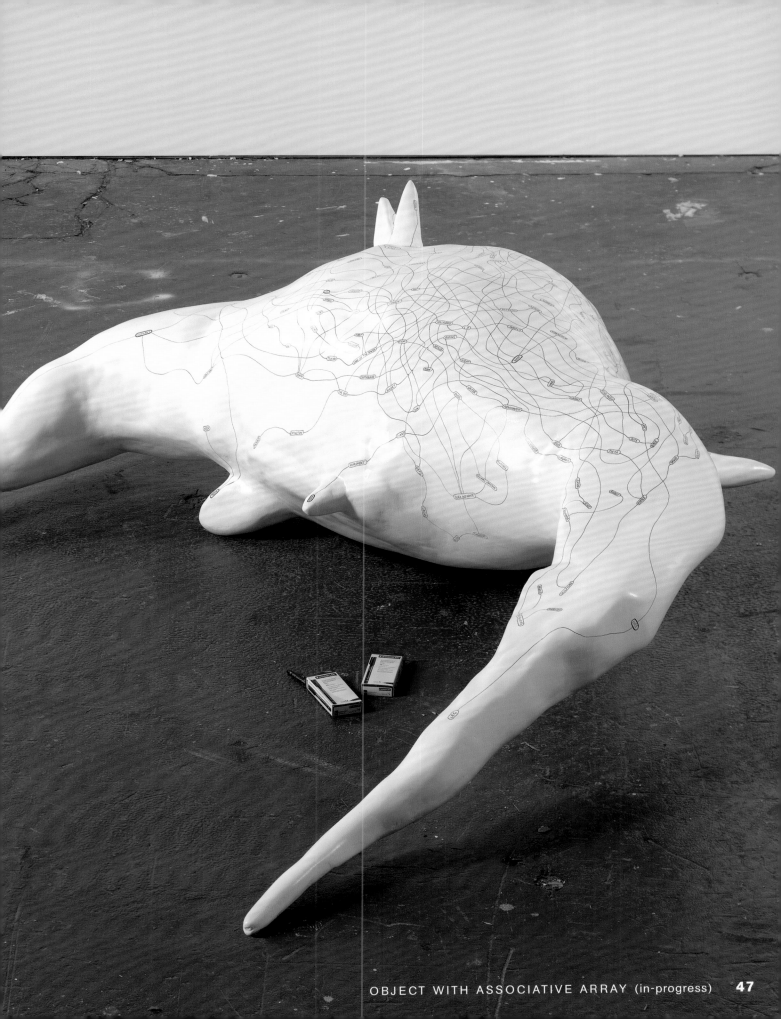

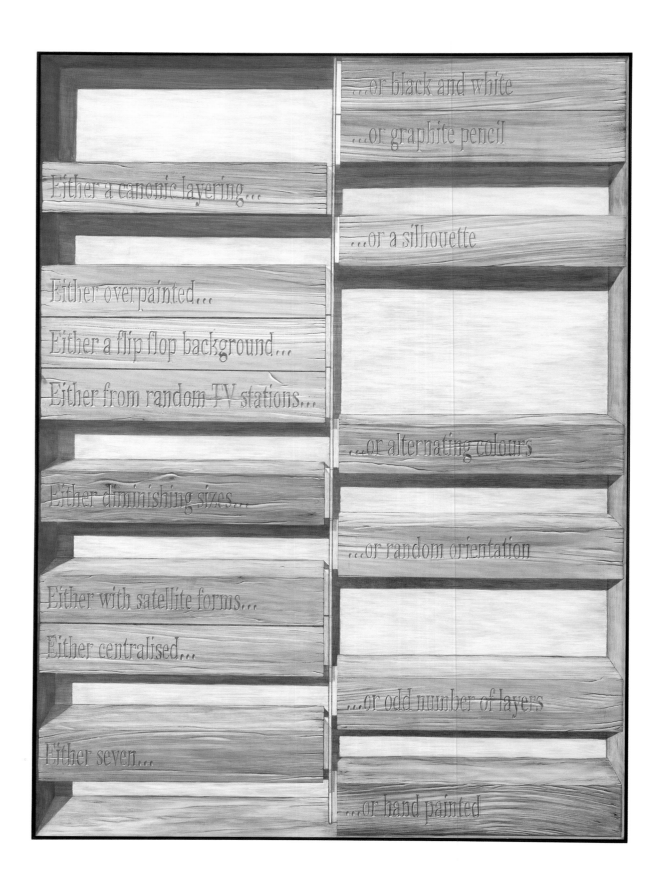

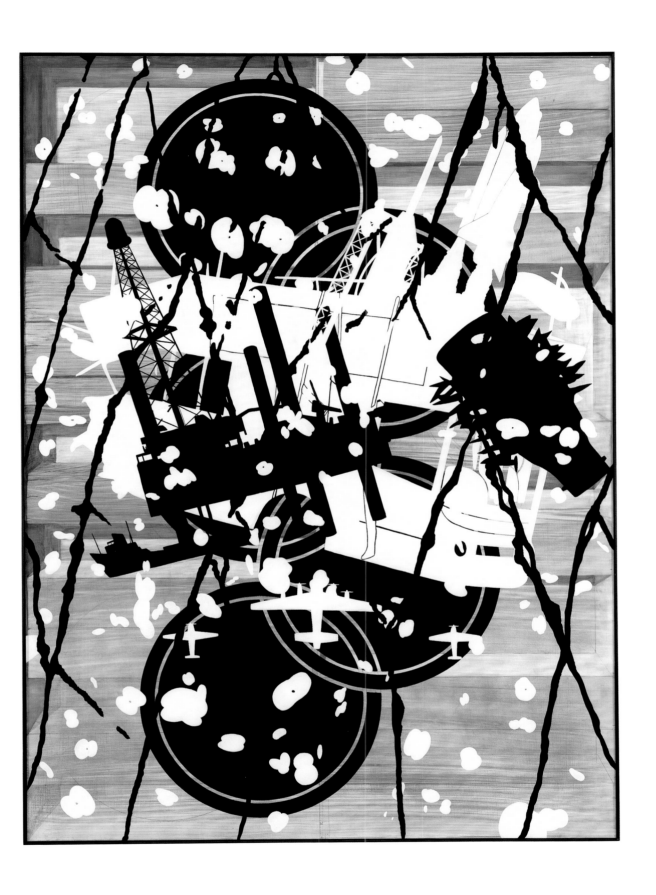

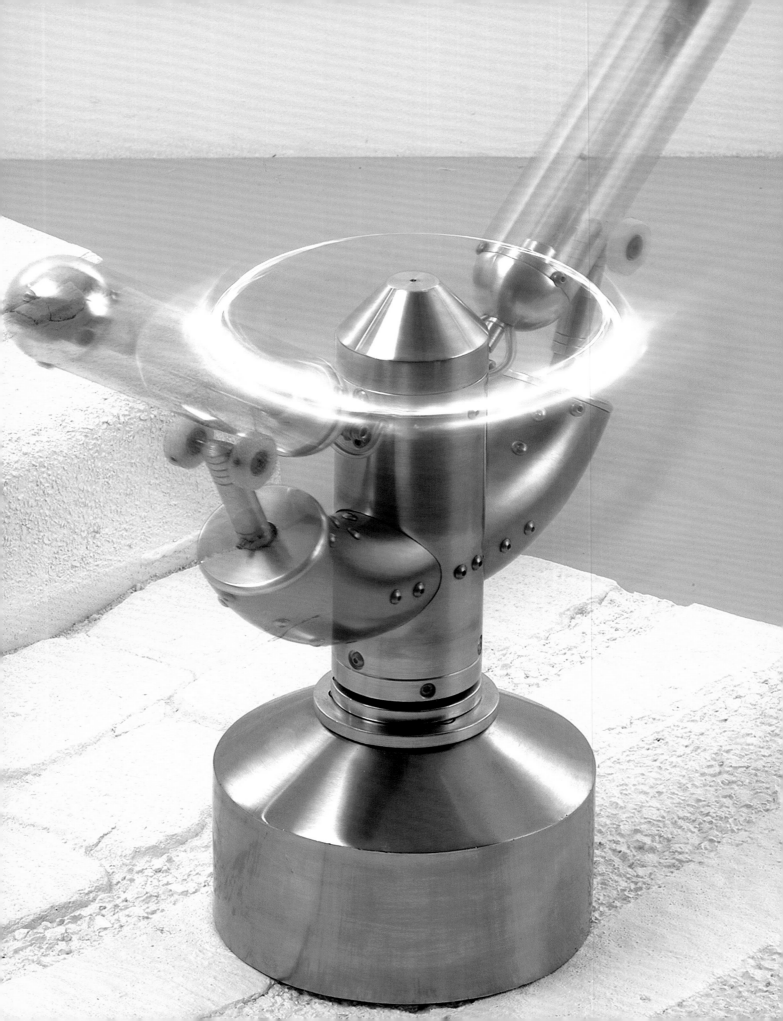

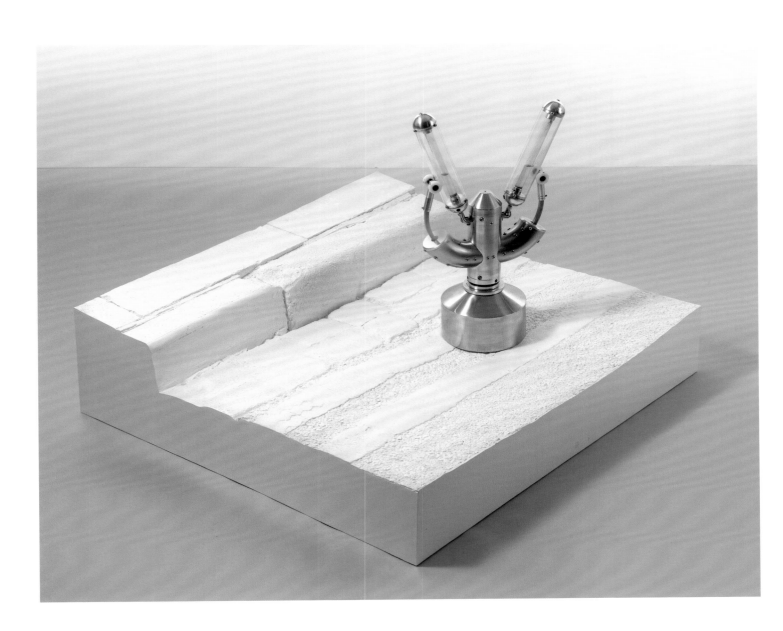

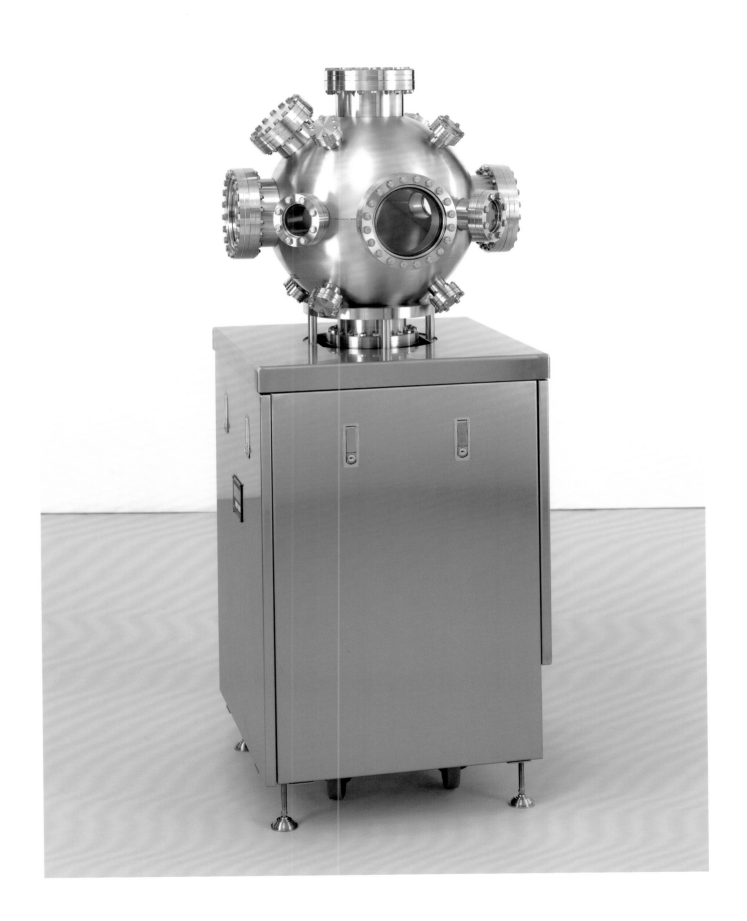

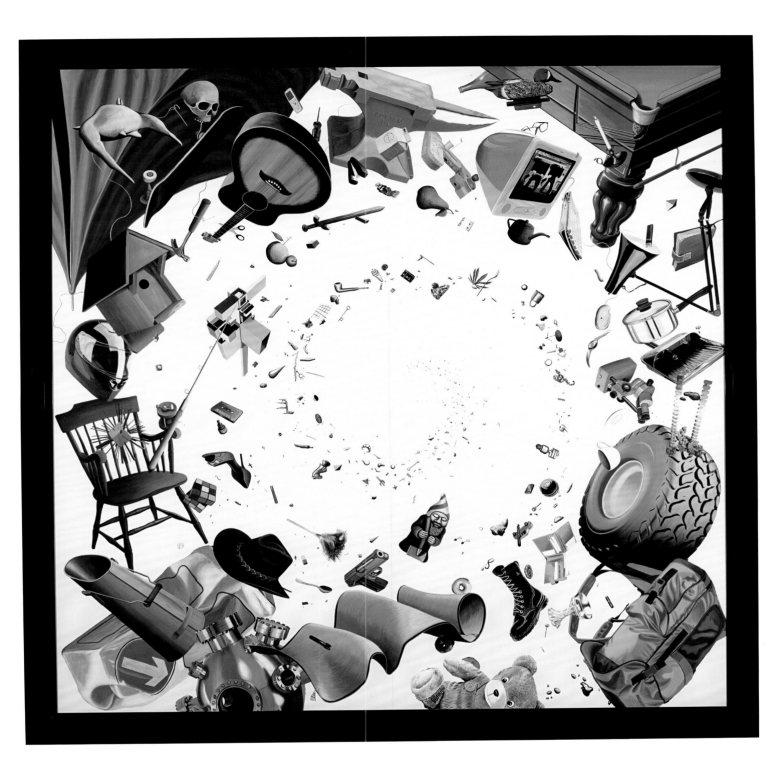

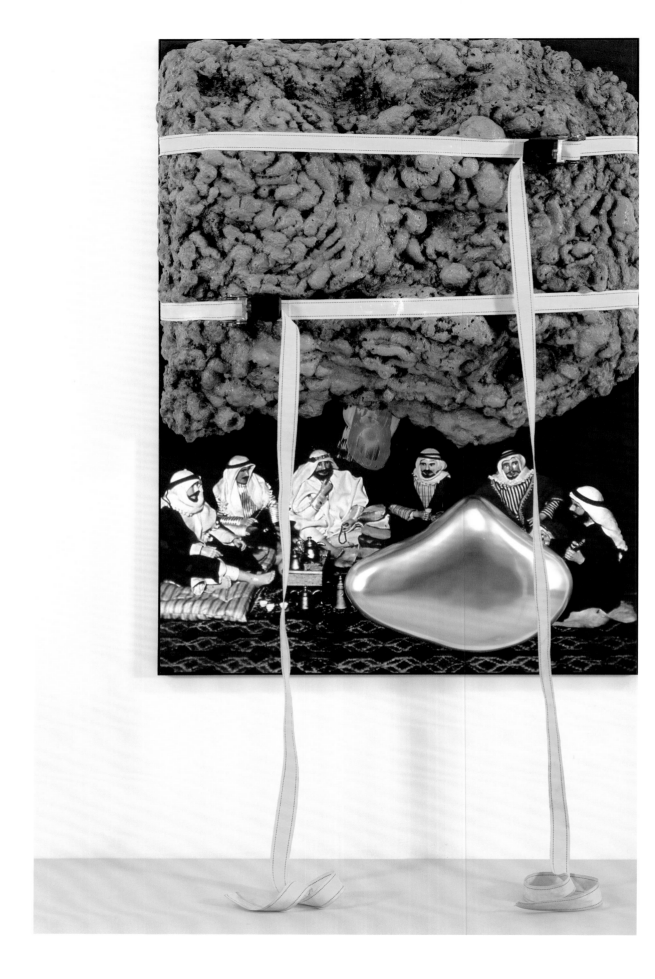

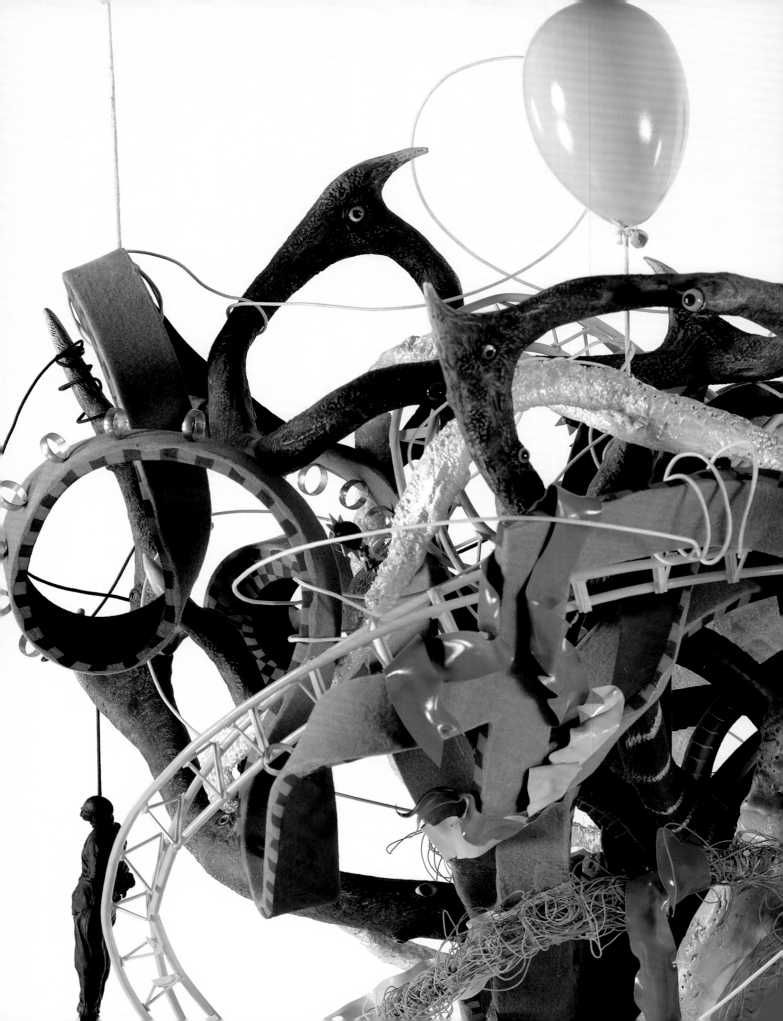

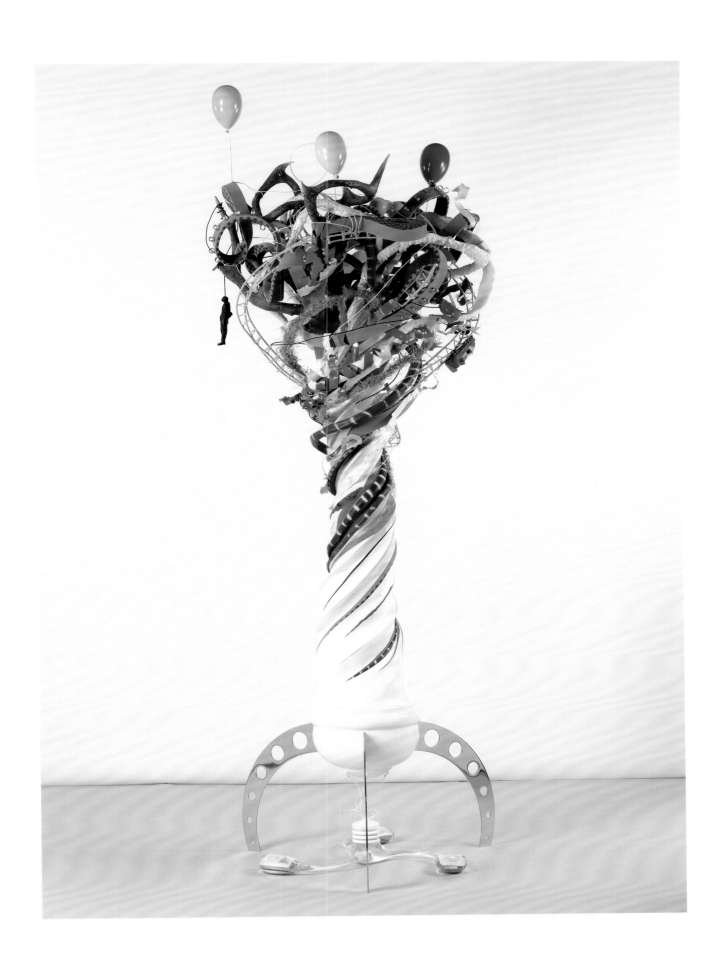

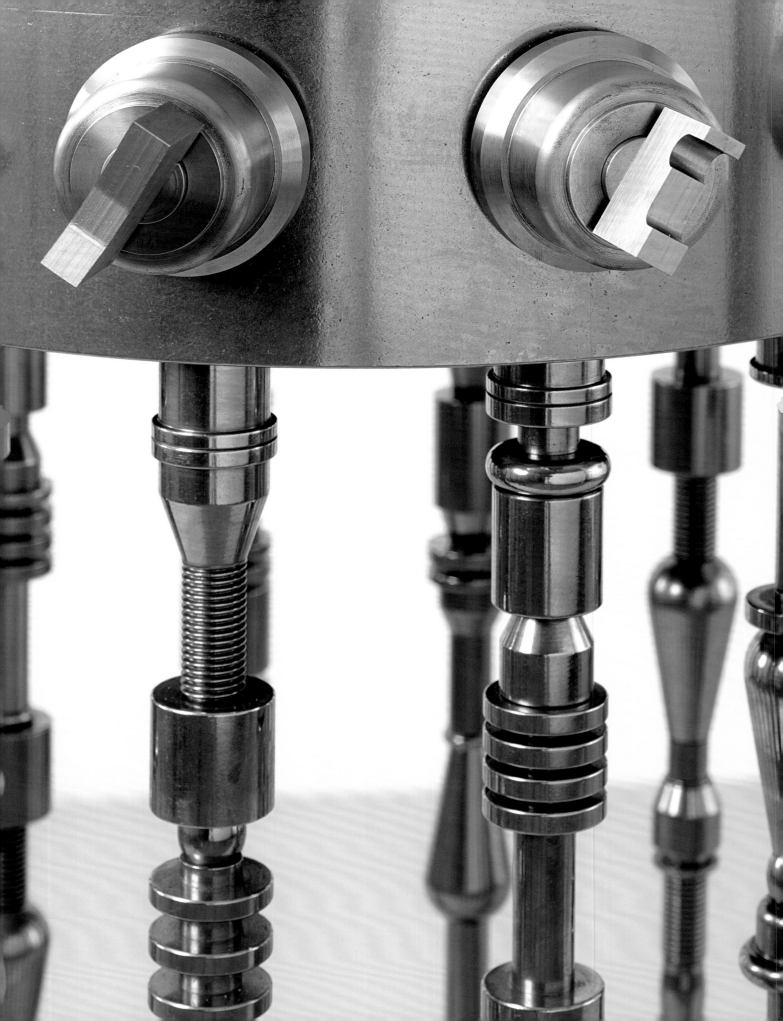

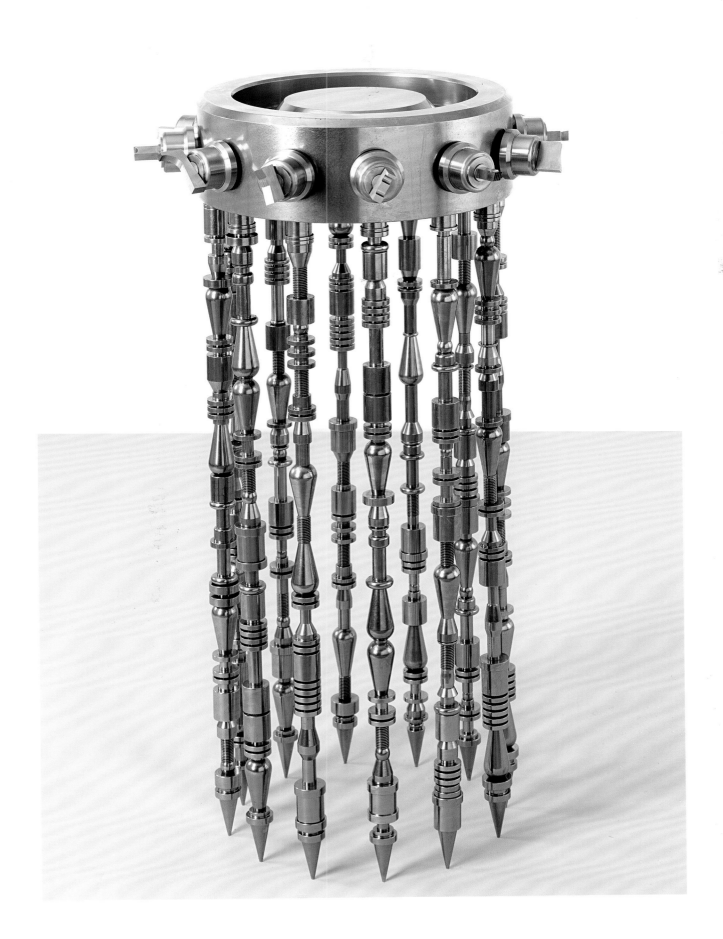

TABLE **61**

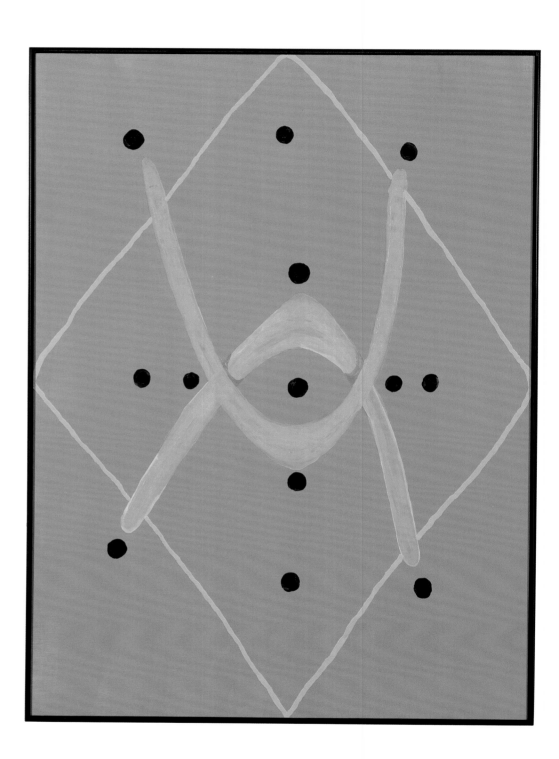

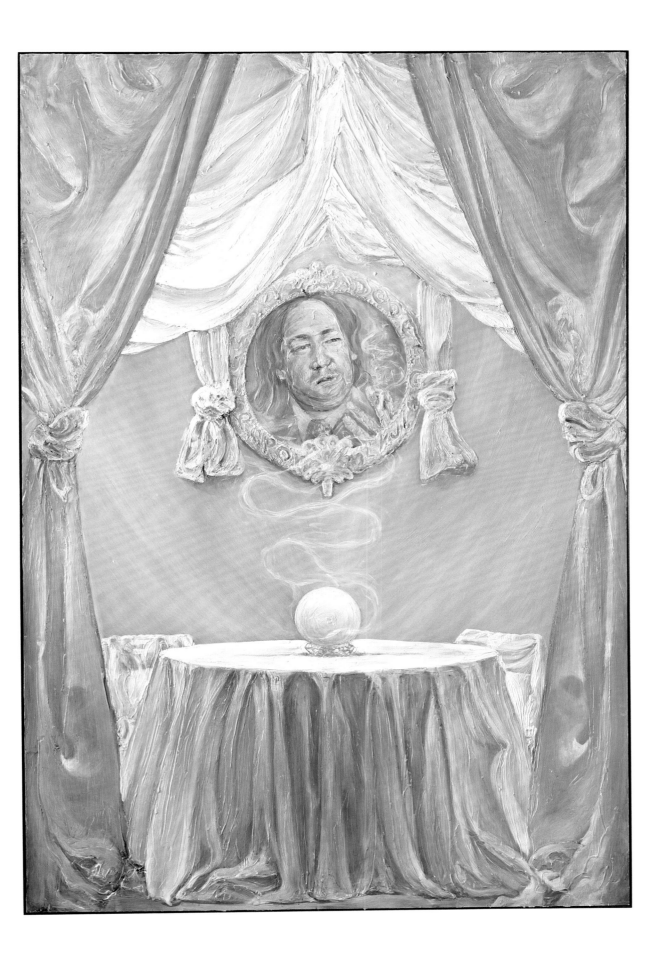

BORN

1969
Ulverston, Cumbria, England.

EDUCATION

1984–1989
Barrow-in-Furness College of Engineering
Mechanical Engineering Craft Studies (M.E.C.S.).

1989–1990
Carlisle College of Art.

1990–1993
University of Brighton, Alternative Practice.

AWARDS AND HONORS

1996
Institute of Contemporary Art: Arts and Innovation Award.

2002
Turner Prize.

2005
Honorary Degree of Doctor of Letters, University of Brighton.

SELECTED ONE-ARTIST EXHIBITIONS

* Catalogue published

1995
From the Artmachine (14 Iterations), Anthony
Reynolds Gallery, London.

1996
David Zwirner Gallery, New York.

1997
Anthony Reynolds Gallery, London.

New Artmachine Paintings, Galerie Georges-Philippe
& Nathalie Vallois, Paris.

1999
*Delfina, London.

Molecular Compound No. 4, Kleines Helmhaus, Zürich.

2000
Studio Wall Drawings, Anthony Reynolds Gallery, London.

One of Each, Galerie Ursula Krinzinger, Vienna.

2002
Supercollider, South London Gallery, London.

*Kunsthalle Zürich.

2003
Collected Short Stories, Galerie Georges-Philippe &
Nathalie Vallois, Paris.

Works from a Teleological Accelerator, Arndt and
Partner, Berlin.

2004–2005
Geno Pheno 1, Haunch of Venison, London.

The Terrible Weight of History, Galerie Judin, Zürich.

Forthcoming:

2005
Geno Pheno 2, PaceWildenstein, New York.

SELECTED GROUP EXHIBITIONS

*Catalogue published

1990

Passive Voyeurs, Stanwicks Theatre Complex, Carlisle, England.

1993

The Space Between, Gallery Fortlaan 17, Gent.

1994

Spit in the Ocean, Anthony Reynolds Gallery, London.

The Observatory, Anthony Reynolds Gallery, London.

1994–1995

**Institute of Cultural Anxiety*, Institute of Contemporary Art, London.

1995

Night and Day, Anthony Reynolds Gallery, London.

1995–1996

**Disneyland after Dark*, Uppsala Konstmuseum, Sweden. Traveled to: Kunstamt Kreuzberg/Betanien, Berlin.

1996

Pandemonium, Institute of Contemporary Art, London.

**Surfing Systems*, Kasseler Kunstverein, Kassel, Germany.

Art and Innovation Shortlist Exhibition, Institute of Contemporary Art, London.

Superstore Deluxe, UP & Co., New York.

Madame ma conscience, Friche Belle Belle de Mai, Marseilles.

**On a Clear Day…*, Cambridge Darkroom Gallery, Cambridge; First Site Gallery, Colchester; Focal Point Gallery, Southend; John Hansard Gallery, Southampton; Institute of Contemporary Art, London; Middlesborough Art Gallery, Middlesborough.

Madame ma conscience (with Gilles Barbier, Alain Bublex, Francesco Finizio, Géraldine Kosizk, Saverio Lucariello, Joachim Mogarra, Sandrine Raquin, Nedko Solakov, Pierrick Sorin, Keith Tyson), Galerie Georges Philippe & Nathalie Vallois, Paris.

In Passing, The Tannery Project Space, London.

White Hysteria, Contemporary Art Centre of South Australia, Adelaide.

1997

Dissolution, Laurent Delaye Gallery, London.

Low Maintenance and High Precision, Hales Gallery and 172 Deptford High Street, London.

**Che cosa sono le nuvole*, Palazzo Rebaudengo, Guarene d'Alba.

**Guarene Arte 97*, Fondazione Sandretto Re Rebaudengo per l'Arte, Turin, Italy.

1997–1998

**Private Face–Urban Space: A New Generation of Artists from Britain*, Old Gasworks, Athens. Traveled to: Rethymnon Centre for Contemporary Art—L. Kanakakis Municipal Gallery, Rethymnon, Crete.

1998

**Il Luogo Degli Angeli*, Museo Laboratorio, Città Sant' Angelo, Villa Bottini, Lucca. (Curator: Renato Bianchini, in collaboration with L'Associazione Ellisse).

Show me the money, 8 Dukes Mews, London.

What's in a name? Anthony Reynolds Gallery, London.

1999

Nerve: cZ1 (happening), Nash Room, Institute of Contemporary Art, London.

1999–2000

**Seeing Time: Selections from the Pamela and Richard Kramlich Collection of Media Art*, San Francisco Museum of Modern Art, San Francisco.

2000

**Over the Edges*, SMAK-Stedelijk Museum voor Actuele Kunst, Gent.

Dream Machines, Hayward Gallery, London, national touring exhibition; Dundee Contemporary Arts; Mappin Art Gallery, Sheffield; Camden Arts Centre, London.

*Urs Fischer "Tagessuppen/Soups of the Days" und
"Domestic Pairs Project" (mit/with Keith Tyson), Kunsthaus
Glarus, Switzerland.

*The British Art Show 5, Edinburgh. Travelled to:
Southampton; Cardiff.

2001

*Century City: Art and Culture in the Modern Metropolis,
Tate Modern, London.

*The Fantastic Recurrence of Certain Situations: Recent
British Art and Photography, Sala de exposiciones del Canal
de Isabel II, Madrid.

*makeshift, University of Brighton Art Gallery, England.

*Nothing, Northern Gallery for Contemporary Art,
Sunderland. Traveled to: Contemporary Art Centre, Vilnius;
Rooseum Malmo and Mead Gallery, Warwick.

*Berlin Biennale, Berlin.

*49 Biennale de Venezia.

*Open Plan P3—The Marathon, Alphadelta Gallery and
Artio Gallery, Athens.

2001–2002

*L' effet Larsen—processus de resonances dans l'art
contemporain (The Larsen Effect: Progressive Feedback
In Contemporary Art), OK Centrum für Gegenwartskunst,
Linz, Austria. Traveled to: Casino-Forum d' Art
Contemporain, Luxembourg.

*Brave New World, Galeria OMR, Mexico City.

2002

*Con Art: Magic/ Object/ Action, Site Gallery, Sheffield.

*Public Affairs, Kunsthaus Zürich.

Strike, Wolverhampton Art Gallery, England.

*25 São Paulo Biennial, São Paulo.

*Flights of Reality, Kettle's Yard, Cambridge and Turnpike
Gallery, Manchester.

2002–2003

*Turner Prize Exhibition, Tate Britain, London.

*Comer o No Comer, Centro de Arte de Salamanca, Spain.

2002–2004

*Reality Check: Recent Developments in British
Photography and Video, Organized by the British Council
and the Photogrphers' Gallery. Traveled to: Moderna
Galerija, Llubjana, Solvenia; Wharf Road, London; Gallery
Rudolfinum, Prague; Poland Bunkier Gallery, Krakow; Latvia
Arsenals, Riga; House of Artists, Zagreb.

2003

The Lost Collection of an Invisible Man, Laing Art Gallry,
Newcastle-upon-Tyne, (brochure).

*Talking Pieces, Museum Morsbroich, Leverkusen, Germany.

Thatcher, Blue Gallery, London.

*Micro/Macro: British Art 1996-2002, Mucsarnok
Kunsthalle, Budapest.

Independence: Issues with a Contemporary Relevance,
South London Gallery, London.

Home, Galerie Georges-Philippe & Nathalie Vallois, Paris.

2003–2004

*Outlook: Contemporary Art Exhibition, Athens.

2004

*Another Zero, Galleria d'Arte Moderna e Contemporanea,
Bergamo, Italy.

Is There A Curator to Save the Show, Galerie Georges-
Philippe & Nathalie Vallois, Paris.

2005

*Logical Conclusions: 40 Years of Rule Based Art,
PaceWildenstein, New York.

*Dionysiac, Centre Geroges Pompidou, Paris.

Summer Group Show, PaceWildenstein, New York.

SELECTED BIBLIOGRAPHY
EXHIBITION CATALOGUES AND MONOGRAPHS

1994
Institute of Cultural Anxiety. London: Institute of Contemporary Art.

1995
Disneyland After Dark. Uppsala, Sweden: Uppsala Konstmuseum.

1996
Surfing Systems: die Gunst der 90er, Positionen zeitgenössischer Art. Basel: Verlag Stroemfeld.

1997
Guarene Arte 97. Turin, Italy: Ed. Fondazione Sandretto Re Rebaudengo per l'Arte.

Private Face—Urban Space: A New Generation of Artists from Britain. Athens: Hellenic Art Galleries Association.

1998
Il Luogo Degli Angeli. Città Sant' Angelo: Museo Laboratorio; L'Associazione Ellisse.

1999
Keith Tyson. London: Delfina Studio Trust.

Ross, David A. *Seeing Time: Selections from the Pamela and Richard Kramlich Collection of Media Art*. San Francisco: San Francisco Museum of Modern Art.

Tyson, Keith. *Molecular Compound No 4*. Zurich: Edition Fink.

2000
Buck, Louisa. *Moving Targets 2 A User's Guide to British Art Now*. London: Tate Publishing.

Coles, Pippa, Matthew Higgs, and Jacqui Poncelet. *The British Art Show 5*. London: South Bank Centre.

Hiller, Susan. *Dream Machines*. London: Hayward Gallery.

One of Each. Vienna: Galerie Ursula Krinzinger.

Over the Edges. Ghent, Belgium: Stedelijk Museum voor Actuele Kunst.

Ruf, Beatrix. *Urs Fischer, Tagessuppen & 6-1/2 Domestic Pairs project (mit Keith Tyson)*. Glarus: Kunsthaus; Zürich: Edition Unikate.

2001
Blazwick, Iwona. *Century City: Art and Culture in the Modern Metropolis*. London: Tate Publishing.

Collings, Matthew. *Art Crazy Nation: The Post Blimey Art World*. London: 21 Publishing LTD., Illus.

The Fantastic Recurrence of Certain Situations: Recent British Art and Photography. Madrid: Sala de exposiciones del Canal de Isabel II.

49 Biennale de Venezia. Milano: Electa; Venice: La Biennale di Venezia.

makeshift. Essays by David Green et al. Brighton, England: University of Brighton Gallery.

The Nothing. Sunderland, England: Northern Gallery for Contemporary Art.

Open Plan P3—The Marathon. Athens: Alphadelta Gallery; Artio Gallery.

2. Berlin Biennale 2001. Cologne: Oktagon.

2002
Bienal Internacional de São Paulo. São Paulo: Fundação Bienal.

Brave New World. Mexico City: Galeria OMR.

Comer o No Comer, o las Relaciones del Arte con la Comida en el Siglo. Salamanca: Centro de Arte de Salamanca.

Curiger, Bice. *Public Affairs: das Öffentlihce in der Kunst*. Zurich: Kunsthaus Zürich.

Flights of Reality. Cambridge, England: Kettle's Yard.

Küng, Moritz. *L' effet Larsen—processus de resonances dans l'art contemporain*. Vienna: Triton.

Ruf, Beatrix. *Keith Tyson*. Zurich: Kunsthalle Zürich.

Turner Prize 2002: An Exhibition of Work by the Shortlisted Artists. London: Tate Publications.

Tyson, Keith. *Head to Hand, Drawings by Keith Tyson*. New York: Powerhouse; London: Turnaround.

158

Tyson, Keith. *A Supercollider Notebook*. London: South London Gallery.

Varola, Helen. *Con Art*. Sheffield: Site Gallery.

2003

Button, Virginia. *The Turner Prize: Twenty Years*. London: Tate Publishing.

Cream 3. London: Phaidon.

The Lost Collection of an Invisible Man. Newcastle-upon-Tyne, England: Laing Art Gallery. (brochure)

Joachimides, Christos M., ed. *Outlook: Contemporary Art Exhibition*. Athens: Adams Publishing.

Micro/Macro: British Art 1996–2002. Manchester, England: Cornerhouse Publications.

Talking Pieces. Leverkusen, Germany: Museum Morsbroich.

2004

Another Zero. Bergamo: Galeria d'Arte Moderna e Contemporanea.

Craig, Patsy. *Making Art Work: Mike Smith Studio*. London: Trolley.

Keith Tyson: History Paintings. Zurich and London: Galerie Judin; Haunch of Veinison.

2005

Keith Tyson: Geno Pheno. New York and London: PaceWildenstein; Haunch of Venison, forthcoming.

SELECTED PERIODICALS

1994

Tyson, Keith. "Streamer." *Mute* (London), pilot edition.

Searle, Adrian. *Time Out* (London), September.

1995

Beech, David. "Strange company the Brady Bunch movie and Keith Tyson." *Artifice* (London), no. 3.

Dorment, Richard. "Science friction." *The Daily Telegraph* (London), 11 January.

Feaver, William. "A strange ghetto of allusions." *The Observer Review* (London), 8 January.

Grant, Simon. "Institute of cultural anxiety." *Art Monthly* (London), February.

"Keith Tyson." *The Times* (London), 10 July.

Morgan, Stuart. "The future's not what it used to be." *Frieze* (London), no. 21, March/April.

Searle, Adrian. "Keith Tyson." *Time Out* (London), 12–19 July.

Tyson, Keith. "Around the Compendium in 54 Aphorisms, (including Jokers)." *Mute* (London), no. 1 (spring): IV, V.

1996

Artists Newsletter, December, illus.

Buck, Louisa. "Silver scene." *Artforum* (International edition), spring.

Dower, Sean. "Video review (Keith Tyson)." *Zap Video Magazine*, spring.

Furniss, Ola. "Weird art." *ID Magazine* (New York), April.

Glueck, Grace. "Keith Tyson." *The New York Times*, 19 July.

Haughton, Nick. *Mute* (London), no. 5.

Kent, Sarah. "Video games." *Time Out* (London), March.

McClellan, Jim. "The art of the implausible." *The Guardian* (Manchester), 31 October, illus.

Negrotti, Rosanna. "Pandemonium." *What's On* (London), 27 March.

"Oxygen of publicity," Londoner's diary. *Evening Standard* (London), 7 March.

Romney, Jonathan. "The in crowd." *The Guardian* (Manchester), 13 March.

Saltz, Jerry. "Keith Tyson." *Time Out New York*, July.

Schauer, Peter. "Britpack's brilliant bargains." *Art Review* (London), autumn, illus.

Searle, Adrian. "Keith Tyson." *Time Out* (London), September.

Tsingou, Emily. "Night and day." *Zing Magazine* (New York), spring.

Tyson, Keith. "The Artmachine," interview with Glenn Brown. *Bomb Magazine* (New York), autumn, illus.

1997

"Keith Tyson." *ID Magazine* (New York), January.

Barrett, David. 'Dissolution', *Art Monthly* (London), April, illus.

Herbert, Martin. "Keith Tyson." *Time Out* (London), 21-28 May, illus.

Beech, Dave. "Keith Tyson." *Art Monthly* (London), June, illus.

Burrows, David. "Low maintenance & high precision." *Art Monthly* (London), September.

Herbert, Martin. "Low maintenance and high precision." *Time Out* (London), 13-20 (August), illus.

1998

Beech, Dave. "Another Tyson ear bending." *Everything 2:3*, illus.

1999

Archer, Michael. "Keith Tyson—Kleines Helmhaus, Zurich." *Art Monthly* (London), October.

Buck, Louisa. "Look out, Damien." *Evening Standard Magazine* (London), 18 June, illus.

Buck, Louisa. "Our choice of London contemporary galleries." *The Art Newspaper* (London), no. 88 (January).

Craddock, Sacha. "Decisions, decisions." *Untitled*, no. 19 (summer).

Gellatly, Andrew. "It's a curse, it's a burden." *Frieze* (London), no. 45 (March–April), illus.

Grant, Simon. "Keith Tyson." *The Guardian Guide* (Manchester), 20–26 March.

Hall, James. "Keith Tyson." *Artforum* (International edition), summer.

Morissey, Simon. "Keith Tyson." *Contemporary Visual Arts* (London), issue 23, illus.

"Production Lines." *Esquire*, May, illus.

Sharkey, Alix. "Artful rockers." *Evening Standard Magazine* (London), 6 August, illus.

Tyson, Keith. Interview by Louisa Buck. *The Art Newspaper* (London), no. 91 (April), illus.

2000

Buck, Louisa. "The next big thing—art." *Evening Standard Magazine* (London), 22 December.

Collings, Matthew. *Observer Guide to British Art*, May.

Time Out Guide to British Art, May.

Ellis, Samantha. "Studio Wall Drawings." *The Evening Standard* (London), 2 June.

Herbert, Martin. *Time Out* (London), 24–31 May, illus.

Hunt, Ian. "British Art Show 5." *Art Monthly* (London), May.

McLaren, Duncan. "Keith Tyson." *The Independent on Sunday* (London), 28 May.

Palmer, Judith. "Hubble, bubble, toil and trouble." *The Independent on Sunday* (London), 6 April.

Sacha Craddock. "Art between politics and glamour." *Tema Celeste* (Syracuse, Italy), July-September.

2001

Besinger, Ken. "View in Venice, Buy at Basel." *The Wall Street Journal*, 15 June, illus.

Darwent, Charles. "Life, the Universe & Everything—a hitchhiker's guide to Keith Tyson." *Modern Painters* (London), winter, illus. and cover.

Falconer, Morgan. "Parallel Universes." *The Royal Academy Magazine* (London), autumn, illus.

Fulcher, Dawn. "Makeshift." *Contemporary Visual Arts* (Bath), no. 33, illus.

Godfrey, Mark. "Venice Biennale." *Untitled* (London), summer.

Herbert, Martin. "Human Mind Mapper." *Art Review* (London), December-January, illus.

Jocks, Heinz-Norbert. "Alles, was zum Menschen gehört- Gespräche mit Harald Szeeman." *Kunstforum International* (Mainz, Germany), Bd. 156, August-October, illus.

"Keith Tyson." FRAME, Biennale Venedig, 8, August/Sepetmber.

Sevastopoulou, Stella. "After the British Storm." *Athens News*, 26 October, illus.

Vele, Ivanmaria and Nicola Carignani, "An Enjoyable Tour of the Venice Biennale." *The Economist*, 23 June.

Withers, Rachel. "A thousand words: Keith Tyson talks about his seven wonders of the world." *Artforum* (International edtion), April.

2002

Alberge, Dalya. "Behold the front page: Times is Turner favorite." *The Times* (London), 30 October, illus.

Archer, Michael. "Keith Tyson." *Artforum* (International edition), March.

"Artworker of the week." *Kultureflash* (London), no. 24 (19 November), illus.

Beasley, Mark. "Keith Tyson." *Art Monthly* (London), no. 254 (March).

Bush, Kate. "Best of 2002." *Artforum* (International editon), December.

Campbell-Johnston, Rachel. "Artist plugs enthusiasm into decade of irony." *The Times* (London), 9 December, illus.

Campbell-Johnston, Rachel. "No painting and no genius for £20,000." *The Times* (London), 31 October.

Campbell-Johnston, Rachel. "The People's Prize." *The Times* (London), 30 October.

Campbell-Johnston, Rachel. "The shock of the now." *The Times* (London), 10 December, illus.

Cowan, Amber. "Amber Cowan's choice." *The Times* (London), 2–8 November, illus.

Cumming, Laura. "Don't shoot the medium." *The Observer Review* (Manchester), 3 November, illus.

Dalya Alberge, 'Turner jury sees art in the most ordinary places." *The Times* (London), 31 October, illus.

Farquharson, Alex. "Keith Tyson, South London Gallery." *Frieze* (London), no. 66 (March).

Field, Marcus."Get your theorems out for the lads." *The Independent on Sunday* (London), 20 January.

G. T. "Humor, logisch." *Frankfurter Allgemeine Zeitung*, 10 December.

Gayford, Martin. "Where the banal and the bizarre collide." *The Daily Telegraph* (London), 16 January.

Gibbons, Fiachra. "Air sickness overtakes porn in Turner stakes." *The Guardian* (Manchester), 30 October, illus.

Gibbons, Fiachra. "The wacky boffin of art takes Turner Prize with dotty diagrams." *The Guardian* (Manchester), 9 December, illus.

Heiser, Jorg. "Der denker." *Süddeutsche Zeitung* (Munich), 10 December.

"Humming obelisk wins Turner Prize." *Metro*, 9 December.

Jury, Louise. "Turner Prize show off the art of controversy (again)." *The Independent* (London), 30 October, illus.

"Keith Tyson wins Turner." *BBC News*, British Broadcasting Corporation, 9 December.

Kent, Sarah. "A good Turner." *Time Out* (London), 6–13 November, illus.

Lack, Jessica. "The Guide." *The Guardian* (Manchester), 12 January.

Leitch, Luke. "Turner winner attacks minister." *Evening Standard* (London), 9 December.

Lister, David. "After all the controversy, Turner Prize goes to artistic thinker." *The Independent* (London), 9 December, illus.

McEwen, John. "More than meets the eye." *The Sunday Telegraph* (London), 3 November, illus.

O'Sullivan, Kevin. "Head-Turner." *Daily Mirror* (London), 30 October, illus.

Orr, James and Charlotte Gill. "The very best of British art: a big black box that hums." *The Daily Mail* (London), 9 December, illus.

"Painter wins top art prize." *Daily Express* (London), 9 December.

Renton, Andrew. "Turner Prize attention is focused on Keith Tyson's…." *Evening Standard* (London), 10 December.

Reynolds, Nigel. "A custard pie for Serota as Turner Prize winner named." *The Daily Telegraph* (London), 9 December, illus.

Reynolds, Nigel. "Fog, chicken and porn: it's Turner prize time again." *The Daily Telegraph* (London), 31 October, illus.

Reynolds, Nigel. "Turner Prize exhibition makes art a dirty word." *The Daily Telegraph* (London), 30 October, illus.

Schurenberg, Barbara. "Die molekule triumphieren uber den bullshit." *Die Welt* (Berlin), 10 December, illus.

Searle, Adrian. "Accessible yet incomprehensible." *The Guardian* (Manchester), 9 December, illus.

Searle, Adrian. "Badly drawn words." *The Guardian* (Manchester), 30 October.

Sumpter, Helen. "Hot Tickets." *Evening Standard* (London), 11 January.

Sumpter, Helen. "The Alchemist." *The Big Issue* (London), 14-20 January.

Thibaut, Matthias. "Beim barte des propheten." *Der Tagesspiegel* (Berlin), 10 December.

Thibaut, Matthias. "Freier Flug ins Nichts." *Der Tagesspiegel* (Berlin), 31 October.

Walsh, John. "Renaissance Men." *The Independent Magazine* (London), 30 November, illus.

Wilsher, Mark. "Appliance of science." *What's On in London*, 9 January.

2003

Barrell, Tony. "Rising to the Equation." *Sunday Times Magazine* (London), 30 November.

Binyon, Michael. "Deface of the nation." *The Times* (London), 18 April.

"Fat and capital as dynamic systems." *The Guardian* (Manchester), 9 January.

2004

Archer, Michael. "Primordial Soups." *Parkett* (Zürich), no. 71

"Art Riddle Competition." *Times Online* (London), 18 October.

Aspden, Peter. "Heady Times for the Biggest Company Art Fair." *Financial Times* (London), 15 October.

Bellet, Harry. "L'Art Fait Recette a la Foire Frieze de Londres." *Le Monde* (Paris), 18 October.

Buck, Louisa. "New Masters." *RA Magazine*, winter.

Campbell-Johnston, Rachel. "This week," exhibition review. *The Times*, Weekend Review (London), 6 November.

Chapman, Peter. "Keith Tyson: Geno/Pheno Paintings." *The Independent* (London), 27 November.

Darwent, Charles. "X Plus Y Equals How to State the Blinkin' Obvious." *The Independent* (London), 7 November, illus.

Davies, Serena. "Empty Games with Genetics." *Daily Telegraph* (London), 11 November.

Farley, Paul. "Endings and Beginnings." *Art Review*, November.

"The Five Best Exhibitions," exhibition review. The Independent: *Review* (London), 8 November.

Gavin, Francesca. "The Meaning of Life at London's Haunch of Venison," exhibition review. *BBC Collective* (online journal), 6 November, illus.

Güner, Fisun. "There's Method in the Madness." *Metro*, 4 November. illus.

Hackworth, Nick. "The Fun of the Art Fair." *Evening Standard*, 15 October.

Hackworth, Nick. "A Man Apart: Keith Tyson." *Dazed and Confused* (London), November.

Hackworth, Nick. "Double-Take On Creativity." *Evening Standard*, 16 November.

"Haunch of Venison is showing Kieth Tyson: Geno Pheno," exhibition review. *Art Newspaper*, no. 152, November, illus.

Higgins, Charlotte. "Frieze in the Frame, Art Scene Booming as Show Draws 150 Exhibitors from Around World." *The Guardian* (Manchester), 15 October.

Lubbock, Tom. "It's A Game of Two Halves." *The Independent* (London) 9 November 2, illus.

Malvern, Jack. "A Work of Art It's OK to Be Puzzled by." *The Times* (London), 16 October.

Parsons, Ben. "Artist was fruit machine addict," exhibition review. *North West Evening Mail* (Barrow and Millon), 5 November, illus.

Ratnam, Niru. "Iron Keith." *Tank* (London), 3, 11 (October).

Reust, Hans Rudolf. "Fabulous Art: Keith Tyson's Research Into Voids For A Weltbild." *Parkett* (Zürich), no. 71.

Searle, Adrian. "Keith Tyson Takes His Chances." *The Guardian* (Manchester), 3 November.

Taylor, John Russell. "Read All About It." *The Times* (London) 10 November, illus.

Tyson, Keith. Interview by Michael Bond. *New Scientist* (London), 20 September.

Verhagen, Marcus. "Keith Tyson." *Art Monthly* (London), December–January.

Wagner, Ethan and Keith Tyson. "A Conversation." *Parkett* (Zürich), no. 71.

2005

Cohen, David. "Arts & Letters-Gallery Going: When the Rule Ruled," exhibition review. *New York Sun*, 3 March.

Cotter, Holland. "Art in Review: 'Logical Conclusions'," exhibition review. *The New York Times*, 18 March.

Güner, Fisun. "Keith Tyson: Geno/Pheno Paintings." *Modern Painters* (London), February.

Harris, Jane. "The ruling class: Seeking the poetic potential of neutral signs," exhibition review. *Village Voice* (New York), 16–22 March: Voice Choices.

MacAdam. Barbara A. "Reviews: New York-Logical Conclusions, PaceWildenstein," exhibition review. *Art News* 104 (June).

Morgan, Robert C. "Reviews: Logical Conclusions, PaceWildenstein, New York," exhibition review. *Tema Celeste* 110 (July–August).

Withers, Rachel. "Keith Tyson." *Artforum*, March.

GENO PHENO **PAINTINGS:**

plate 1: **Two Curves** 2004
acrylic on aluminum, 33 ½ x 50 ½" (850 x 1280 mm)
Private Collection

plate 2: **Two Frame Teen Flick** 2004
acrylic on aluminum, 48 ½ x 68 ½" (1230 x 1740 mm)
Private Collection, London

plate 3: **The Six Fingered Salute** 2005
acrylic on aluminum, 33 ½ x 50 ½" (850 x 1280 mm)

plate 4: **Thirteen Swords** 2004
acrylic on aluminum, 48 ½ x 68 ½" (1230 x 1740 mm)
Private Collection

plate 5: **A Thousand Marks** 2005
ink and acrylic on aluminum, 96 ½ x 134" (2450 x 3400 mm)

plate 7: **All That There Was** 2005
mixed media on aluminum, 33 ½ x 50 ½ x 8" (850 x 1280 x 200 mm)

plate 8: **Angled Like a Budding Rose** 2004
mixed media on aluminum, 33 ½ x 50 ½" (850 x 1280 mm)
Private Collection

plate 10: **Belladonna** 2004
acrylic on aluminum, 66 ½ x 98" (1690 x 2490 mm)
Private Collection

plate 11: **The Bigger Picture Emerges** 2004
acrylic on aluminum, 132 x 198" (3350 x 5030 mm)
Collection Pinault

plate 12: **Brownstone (A Five Day Test)** 2005
acrylic on aluminum, 66 ½ x 98" (1690 x 2490 mm)

plate 13: **Call of the Wild** 2005
charcoal and acrylic on aluminum, 48 ½ x 68 ½" (1230 x 1740 mm)

plate 14: **Celestial Crown** 2004
ink and acrylic on aluminum, 33 ½ x 50 ½" (850 x 1280 mm)
Private Collection, UK

plate 19: **Dick Dastardly's D.N.A.** 2005
acrylic on aluminum, 48 ½ x 68 ½" (1230 x 1740 mm)

plate 20: **Dismantled Confluence** 2005 (in-progress)
ink on aluminum, 96 ½ x 134" (2450 x 3400 mm)

GENO PHENO SCULPTURE:

plate 6: **7776+1 (Cutting the Fungal Cord)** 2005
steel, MDF, GRP, glass, synthetic milk, and pump
144 x 108 1/4 x 108 1/4" (3660 x 2750 x 2750 mm)

plate 9: **Automata No. 1** 2005
foam, lacquer, acrylic, and epoxy resin
66 1/2 x 32 1/2 x 32 1/2" (1690 x 830 x 830 mm)

plate 15: **Chameleon** 2005
plinth and renewable advertising contract
48 x 24 x 24" (1220 x 610 x 610 mm)

plate 16: **Covert Polyhedron** 2005
mild steel polyhedron on punched steel block
68 x 22 x 23 5/8" (1730 x 560 x 600 mm)

plate 17: **A Deeper Mining of the Causal Vein** 2005
GRP, leather, rubber, plastic, Lego, steel, MDF, ceramic tiles,
resin, straw, veneer, concrete, plastic bucket, and tap
68 x 126 x 87 1/2" (1750 x 3200 x 2220 mm)

plate 18: **A Dendrochronological Library** 2005 (in-progress)
bookcase, 100 years of books with a dendrochronological bore
and 100 suspended objects

plate 21: **The Draw of Unseen Stars** 2005
painted GRP sculpture on a rubber, paint, wood, steel,
hessian, flowers, and stone strata
53 1/2 x 39 3/8 x 39 3/8" (1360 x 1000 x 1000 mm)

plate 22: **As Echoes Distort a Fortress** 2005
GRP, steel, and glass
87 3/4 x 55 x 55" (2230 x 1400 x 1400 mm)

plate 24: **Fractal Dice No. 1** 2005
aluminum and plastic
36 x 212 x 45" (914 x 5385 x 1143 mm)

plate 25: **Globe of Shit** 2005
illuminated globe, tourists' souvenirs, glue, and brown paint
60 1/4 x 60 1/4" (1530 x 1530 mm)

plate 30: **If That Then This** 2005
silicon bronze, and glass
3 x 20 x 20" (76 x 510 x 510 mm)

169

GLOSSARY

ABSOLUTE ZERO A condition in which the energy level of the system falls to a point at which all movement on the atomic level ceases, making this temperature (-273 degrees C or -459 degrees F) the minimum point for all temperature scales.

ALGORITHM Any mathematical equation which functions as an instruction in a generative process.

ANTHROPIC PRINCIPLE Concept developed in the early 1970s that the fundamental principles of the universe are "fine tuned" to produce life.

ARCHIMEDES SPIRAL Like the shell of a nautilus, Archimedes spiral is a form built from the circularly expanding expression of Fibonacci's sequence, a sequence of numbers generated by adding the prior digit in the sequence to the current digit to derive the next digit; 0,1,1,2,3,5,8,13,21…. Such spirals are common in nature and appear to be characteristic of many "growing" systems.

ARTIFICIAL Dubious qualifier designating a paradoxical separation from nature.

AUTOMATA A machine designed to follow a set of pre-established instructions, thereby allowing it to generate a material expression of that rule set.

BOOLEAN LOGIC The system by which "off or on" signals, such as those generating in computers (see flip flop gates), can be assembled to express and carry out logical rules and operations.

CANON (MUSICAL) A imitative system of music in which a theme follows itself according to some repeating pattern (e.g. row, row, row your boat).

CAUSALITY The persistent philosophical alternative to fate, magic, destiny, and choice. This principle that any event or reality is the direct result of the mechanical combination of existing forces and starting conditions. As such, causality has played one side of most of the dualities which have characterized intellectual discourse from the Enlightenment till today; Determinism vs. Free Choice, Mind vs. Brain, Reflex vs. Volition.

COINCIDENCE Events happening in close temporal proximity which are assumed to have a causal link, despite any evidence to that effect.

CONWAY'S GAME OF LIFE Invented in 1970 by the Cambridge mathematician John Conway, the *Game of Life* is a two-dimensional grid, populated by "cells," and governed by a simple set of birth, death, and survival rules. Each of the cells can be in one of two states: alive or dead. Beginning with any given initial pattern of live cells, one can employ Conway's rules in order to determine the behavior of the cell population over any number of generations or time steps. Whether a cell survives, dies or comes into being is determined by rules regarding the number of live neighbors the cell has. Each cell has eight possible neighbors (four on its sides, four on its corners).

CURVE Any line which results from the joining of points generated by applying multiple values to the variables of a single equation. Also defined as the juxtaposition of an infinite number of infinitesimal straight lines.

DEATH The mechanism by which the apparently anti-entropic behavior of complex systems, which appear to drive matter into more and more organized states, are re-balanced within the larger thermodynamic scheme.

DENDROCHRONOLOGY Originally the term for investigating the history of a tree by examining the cross-sectional rings. More generally, it refers to study of the past through the use of core sampling and/or cross-sectioning of any accumulated material.

ENTROPY Also known as the second law of thermodynamics, it is described as the tendency for all systems to proceed towards a state of maximum randomness.

FLIP FLOP GATE A mechanism for turning a change of input, such as a drop in voltage or a change in the color of laser light, into an on or off binary output.

FRACTAL A mathematical expression of the randomness of a system.

GENOTYPE Any system with the ability generate some number different results—e.g. a six-sided die which could generate any of six results, a particular pair of parents, one with blue eyes, one with brown eyes, that could potentially produce a child with one of two possible eye colors.

HYPERCUBE A four-dimensional permutation of a three-dimensional cube, just as a cube is the three-dimensional permutation of a square. Due to the apparent lack of a fourth spatial dimension in our universe, it is impossible to construct a hypercube, however, just as a cube can be depicted on a two-dimensional surface, a hypercube can be depicted in three.

INDUCE To direct a logical inquiry from pure observation to the development and testing of a hypothesis, as distinct from deduction which proceeds from hypothesis to observation.

INERTIA Result of Newton's first law of Motion; a body in motion shall remain in motion and a body a rest shall remain at rest until acted on by an outside force. e.g. colliding billiard balls.

IRREDUCIBILITY A system which is being observed at its most basic level beyond which more fundamental elements cannot be subdivided out (see Quantum).

ISOTROPIC UNIVERSE Principle that the universe, though apparently "clumpy" and heterogeneous when we observe it, is, in fact, at the largest scales smooth, homogenous and isotropic (see Zen).

JUMP To proceed directly from a starting point to an ending point by condensing everything in between into a single step.

LORENZ ATTRACTOR A simple set of equations developed in the 1960's by a meteorologist studying atmospheric convection. The result was an expression of chaotic systems whose behavior while non-linear and unpredictable, could be observed to be powerfully affected by even minute changes in starting conditions. This equation led to the coining of the popular metaphor, the butterfly effect.

Cover:
All That There Was, 2005 (detail)

Special thanks:
Nick Dowdeswell
Calum Sutton

Photography:
Digital image courtesy of Paul Bourke; page 18 (fig. 3)
Digital image courtesy of Edward Pierce Studio; plate 34
Kerry Ryan McFate / Aram Jibilian; plates 9, 15
Dave Morgan, FXP Photographhy / Courtesy Haunch of Venison, London; pages 6 (fig. 1), 18 (fig. 2)
Prudence Cuming Associates, London; plates 3, 5–8, 12, 13, 16–26, 28, 30, 31, 33, 35–37, 39, 42, 43, 47–51, 53–63, 65
Richard Valenica / Courtesy Haunch of Venison, London; plates 1, 2, 4, 10, 11, 14, 27, 29, 32, 38, 40, 41, 44–46, 52, 64, 66

Design:
Tomo Makiura

Production:
Paul Pollard
Tucker Capparell

Color Correction:
Motohiko Tokuta
Antony Makinson

Printing:
Meridian Printing, East Greenwich, Rhode Island

Library of Congress Control Number:
2005908350

ISBN:
1930743505